# STAR WARS®

# THE ART OF DAVE DORMAN

edited by Stephen D. Smith and Lurene Haines

FPG

2539 Washington Road, Building 1000
Pittsburgh, PA 15241

STAR WARS®: THE ART OF DAVE DORMAN
by Dave Dorman
edited by Stephen D. Smith & Lurene Haines
©1996 Lucasfilm Ltd.
final editing by John Zaphyr (FPG)
and Allan Kausch (Lucasfilm)

Published by FPG
2539 Washington Road, Building 1000
Pittsburgh, PA  15241

designed by Stephen D. Smith

Library of Congress Catalog Number:  96-085101
ISBN 1-887569-37-5
First edition, August 1996

Distributed by Ballantine Books, a division of
Random House, Inc.
201 East 50th Street
New York, NY  10022

Printed in Hong Kong

*A catalog of licensed Star Wars® and other art prints and
merchandise by Dave Dorman is available from:
Rolling Thunder Graphics
P.O. Box 203 • Mary Esther, FL 32569*

# Acknowledgments

This book is dedicated, with love,
to my father John and my late mother Phyllis,
whose love and patience allowed me to spread
my wings and explore artistic frontiers.

---

Special thanks must go to a number of people.
(good thing this isn't a televised awards show!)

Thanks to my Lucasfilm family; Howard Roffman, Julia Russo, Lucy Autrey
Wilson, Sue Rostoni, Allan Kausch, Kathleen Scanlon, Stacy Mollema, Yvonne
Nolasco and everyone else at Lucasfilm Licensing who has helped me gather
reference, answered my questions and for just being there.

At Dark Horse, I'd like to thank Mike Richardson, Diana Schutz, Barbara Kesel,
Ryder Windham, Dan Thorsland, and Bob Cooper. A special thank you to
Tom Veitch and Cam Kennedy for starting us all out.

Thanks to Judy Murello at Berkley Books for being as good a friend
as she is an art director.

Thanks also to the friends and family who have posed for me over the years; Phil
Burnett (a hero in every sense of the word), Del Stone, Jr., my lovely wife Lurene,
Chris Smith, Kris Lagerloef, Kristin Marshall and Calvin Engel.

A special thanks, from deep in my heart, to my contributors on this project; Steve
Smith and my wife, Lurene. Steve spent many a sleepless night bringing this book
together at the last minute, and if I thanked Lurene for every single thing she
does, we would quickly run out of space. Without them, this book would not exist.

To Kevin J. Anderson, thanks for the intro!

To Michael Friedlander for taking a chance on us.

And a deep debt of gratitude and thanks to the man who began all this more than
20 years ago... GEORGE LUCAS!
Your spark of imagination set us all off on this wonderful adventure.

—Dave

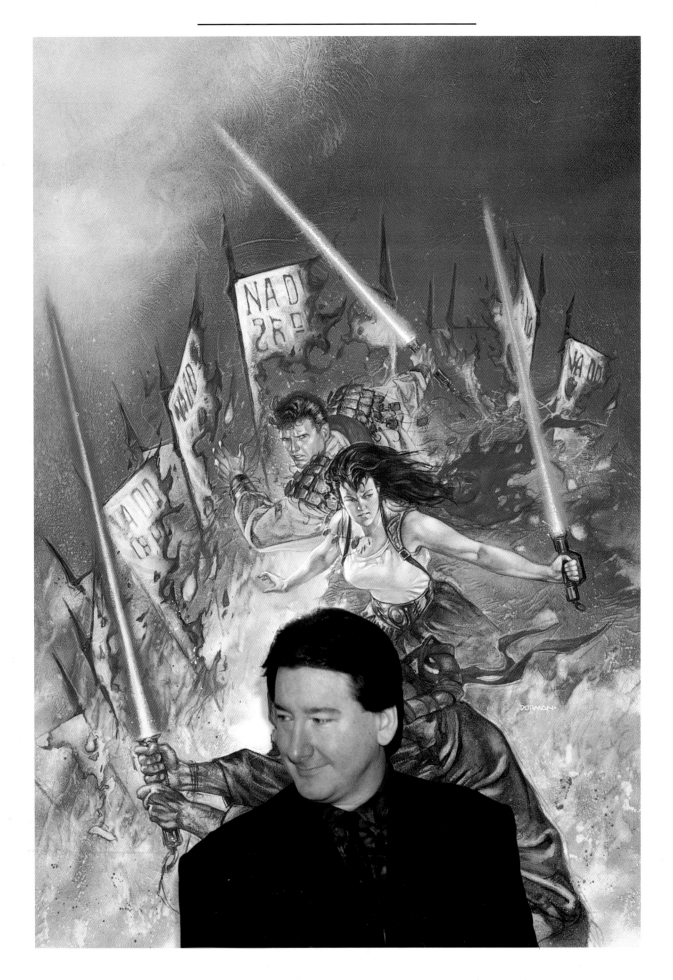

# Introduction

Kevin J. Anderson

The San Diego Comic Con, for those of you who are uninformed, is an annual gathering of about a billion comic fans, media personalities, publishers, editors, comic writers and, of course, the artists, all sweeping through the San Diego convention center like a pack of Jawas descending upon a scrap heap marked FREE DROID PARTS.

Seizing the opportunity to talk face-to-face about cover art for one of our upcoming *Star Wars* novels, my wife Rebecca and I arranged to meet Dave Dorman in his lurking spot in a place called "artists' alley." In those rows of open tables, comic artists (both new hopefuls and old pros) hocked their wares, whether they be limited-edition prints, caricatures drawn to order, or old pencils from published comic pages. We figured it wouldn't be hard to find Dave.

Of course, we didn't realize that every other fan was looking for him as well, and they all managed to get there five minutes ahead of us!

I had first encountered Dave's work years earlier in the visceral *Aliens: Tribes* from Dark Horse Comics, for which he was awarded the Eisner Award. After that project, I began to notice the distinctive Dorman style and vibrant color palette on many additional comics; particularly the spectacular covers for the six issue mini-series *Star Wars: Dark Empire*, which you will see here.

Tom Veitch (author of *Dark Empire)* had gotten in contact with me while trying to interweave his comic story with my Jedi Academy trilogy of novels. Tom had sent me his scripts and outlines, so I was already thoroughly familiar with the terrific storyline by the time I got to see the comics in print. But when coupled with Cam Kennedy's interior art and Dave's covers, the true spirit of *Star Wars* seems to have been captured in each issue.

Back at the Con, working our way down "artists' alley," Rebecca and I finally managed to wrestle our way to the front of Dave's line of eager fans and slip behind the table where we could poke around at the posters, prints and sketches he kept stashed beside him while he finished signing "just a few more autographs." Finally, during a millisecond-long break, Dave's wife Lurene brought out a small color photograph of Dave's newly completed painting for our fourth Young Jedi Knights book, *Lightsabers*. The piece is truly a jaw-dropper, probably my favorite of the first six covers in the series.

Naturally, the appearance of this new work caused yet another crowd to gather, and so we had to postpone our meeting for a few more minutes.

The previous year at the San Diego Comic Con I had met Dave for the first time, and he tantalized me by promising to show me his new cover for our first Young Jedi Knights book. "I've got it here somewhere..." Since cover art can make or break a book, and since this was the start of a major new *Star Wars* series, Rebecca and I were naturally most anxious to see it. But sadly, the sketches and color prints had been left back in Florida. So, we had to content ourselves with looking at Dave's new paintings for *Dark Empire II*, many of which have now been reprinted as trading cards for Topps' *Star Wars Galaxy* series. Dave has done other work for Topps too, including the original "Droids Only" painting and a cover for *Star Wars Galaxy* magazine.

Stepping into a different time period entirely, four thousand years before the setting of the films, Dave also helped to create the "medieval *Star Wars*" feel for the launch of Tom Veitch's new comic series *Tales of the Jedi*, which presented the challenge of conveying dramatic *Star Wars* scenes without using any recognizable main characters.

To capture the flavor of George Lucas's universe, he tapped into potent emotions, particularly the glory of the Jedi Knights represented by the stark despair yet perpetual hope shown by Nomi Sunrider as she cradles her baby and kneels beside her fallen husband.

Finally, returning to the comic con once again, we managed to flee "artists' alley" with Dave in tow and grab a newly emptied (but not yet cleaned) table in the crowded cafeteria, where we could safely brainstorm ideas for the cover of Young Jedi Knights #6: *Jedi Under Siege*. This was to be the climax to the first six-novel story arc, so the cover had to contain all the major elements, all the spectacle of a final confrontation. Rebecca and I tossed out ideas as Dave jotted them down, sketching out a few arrangements: the Emperor's brooding eyes, the heroes and villains engaged in lightsaber battles, explosions, TIE bombers, etc. Somehow, in the following months, Dave managed to integrate all the major elements into that final cover...

Here, in this book, readers can finally see the Young Jedi Knights paintings without the metallic etching, in all their glory. (That etching sure sells books but unfortunately it murks up the careful details dropped into the artwork.)

When I first learned that Dave Dorman would be painting our Young Jedi Knights covers, my wife and coauthor had, at that time, very little background in comics and so she did not recognize his name. But she could certainly see that I was ecstatic. "What is it?" she asked. "What's so exciting?"

Then I showed her Dave's work.

And here you can see the work too— uncluttered by titles and credits and logos and foil etchings. Just Dave Dorman's paintings by themselves... and that's all you need.

—Kevin J. Anderson

*Kevin J. Anderson is the author of numerous* Star Wars *novels and comics, including the Jedi Academy trilogy (Bantam),* The Sith War *(Dark Horse), and with his wife, Rebecca Moesta, the Young Jedi Knights Series (Berkley).*

# Dorman and Star Wars

*It was in late 1975 that a Maryland high school student first read about a new science fiction film in* Cinefantastique *magazine. Already an avid film fan and admirer of the old Flash Gordon serials that had aired on his local channel, he grew excited by the idea of a big-budget film of that style. At the time, Dave Dorman had no idea that* Star Wars *would become such a phenomenon or that his life would become inextricably entwined with that sensation.*

"In the fall of 1976, I was a Fine Arts major at St. Mary's College of Maryland; located about two and a half hours south of Washington, DC. While I was at college learning the basics in art, I became focused through my exposure to comics. It was the great storytelling by Jack Kirby, Stan Lee and Jim Steranko at Marvel Comics that first attracted me to comics like *Captain America* and the *Fantastic Four*. But it was the elements of science fiction and high drama that stimulated me artistically, focused me to capture that spirit in my own drawing. Then, I became more interested in painting. During that year of college, I took many painting classes and tried to learn as much as possible about art. I also tried to watch as many sci-fi movies as I could, since that was also an interest of mine. I stayed in touch with the movie industry through magazines, while news kept trickling down about this new film named *Star Wars*.

Then, in late 1976 or early 1977, I ran across a book; *Star Wars* by George Lucas. The cover and title jumped right out at me since I was familiar with the movie news. The back cover read "Soon To Be A Major Motion Picture," so I bought the book. I read it fairly quickly; it was an exciting story. When I finished reading, I thought if the moviemakers could capture just half of what was in the book on screen, then this movie was going to be a blockbuster. Soon movie trailers started to

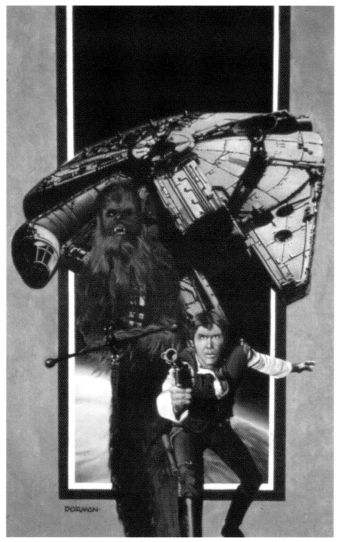

*Han Solo and Chewbacca (circa 1981).*

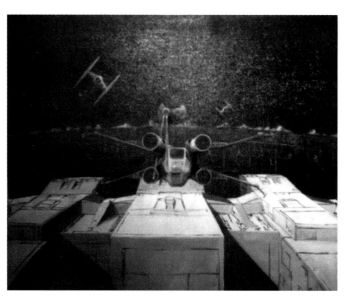

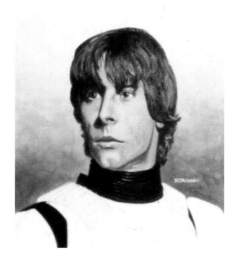

*(above) Attack on the Death Star from 1978.*
*(below) Portrait of Luke Skywalker from 1979.*

run, and word of mouth was being generated in the science fiction fandom. As anticipation for the movie built, the excitement grew as well.

Finally, in early May of 1977, news spread that the film was going to be released later that month. I immediately made plans to view one of the first showings. I planned to attend a screening on opening night at the Uptown Theater in Washington, DC. I knew it was a cavernous, plush theater, a perfect place to view a movie, but what I didn't know was that the Uptown was one of the few theaters in the country showing a 70mm stereo print of the film. At the time, this was very unusual.

The big day arrived the morning of May 25th. I skipped my classes, got in my car and made the two and a half hour drive (stopping-in at my folks to say a quick hello) into Washington to see the movie. By the time I arrived, there was a very long line—almost around the block. Everyone was excited to be there on opening day. Unfortunately, I couldn't get in to see that first showing but I was there for the second. Let me say, it was well worth the drive.

The movie was exactly what I'd hoped it would be. It was incredible to be in that theater at that time. With the huge screen and the surround sound, it was like a multi-media experience. The movie was thrilling, with a great group of protagonists. It was funny, heroic, and action-packed. With the excitement of the battles, and the thrill of the Death Star trench chase scene, it was an emotional roller coaster ride. And the way the film was edited gave the sensation that you were there, really moving.

Despite what you might think, reading the book first had not ruined the experience at all. The movie really drew me in with its visuals and the John Williams music score. And the direction of George Lucas kept it very fast-paced and entertaining. The special effects were truly unique for that time period; they just knocked you out of your seat. Before this movie, science fiction moviemaking had featured sleek, clean glimpses of the future. *Star Wars* took that genre in a whole

new direction. The film designers, under George Lucas's direction, had chosen to make this film look very "lived-in." In this universe, things got used, things got dirty, things weren't all sleek and clean. Those images added a sense of realism to the visuals and it made the film much more visually interesting to me.

All of these factors inspired me to look at science fiction art in a new way. Up until that point, I had been trying to develop my style, to find my artistic voice. I was still working on the basics of painting and drawing, and my anatomy skills needed work. As a result, most of the paintings I did during that period were very unpolished. That all began to change after *Star Wars*.

I was not the only one effected by *Star Wars*. The film seemed to strike a chord with the country, and to take advantage of this fascination, a huge media blitz began. It seemed every magazine and newspaper in the country was doing articles on *Star Wars*, and I was gobbling all of it up. That summer, I bought a 16mm copy of the *Star Wars* trailer and borrowed a projector from my old high school. I watched it over and over again as if it was the Zapruder film, studying every detail. While I had the projector, I signed-out from the public library 16mm copies of classic films; *Battleship Potemkin, Nosferatu, The Cabinet of Dr. Caligari*, and Windsor McKay's *Gertie the Dinosaur*. These were movies I had only read about, and had not seen before. As you can tell, the *Star Wars* film really reignited my interest in science fiction and fantasy films.

During that summer of 1977, before I attended The Joe Kubert School, I attempted to incorporate some of the *Star Wars* material into my own art. My initial experience doing *Star Wars* artwork was with promotional material used as reference, like photographs of X-wing fighters and preliminary artwork. I produced some very crude X-wing paintings, trying to capture some of the fun of the movie, and to experiment with painting too.

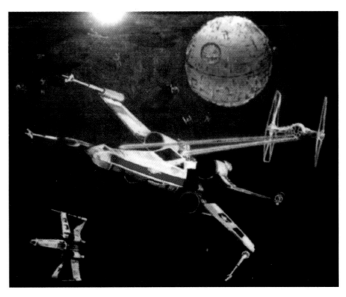

*(above) X-wing battle from 1978.*
*(below) Early portrait of Han Solo from 1978.*

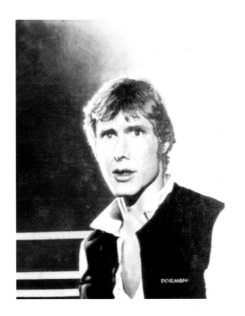

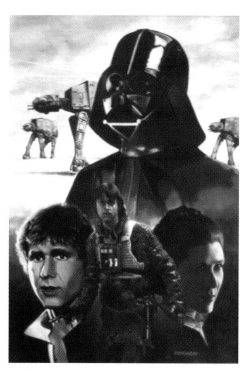

*A 1982 montage for* The Empire Strikes Back, *foreshadowing Dave's growing interest in creating movie poster-style art.*

In the fall of 1978, I attended The Kubert School to learn how to draw comics. I stayed for only one of the two-year program, but I did learn a lot about artwork and creating comics. However, at that time, the school taught only black and white work, and I wanted to paint. Thankfully, my parents were very supportive and let me stay home to develop my work. That summer, I did portraits of Luke and Han, marking the first time I began to gain confidence in rendering people's likenesses.

In 1980, my family moved to Florida. I was still trying to build my portfolio and work up samples. One was a portrait of Han and Chewie with the *Millennium Falcon*. At the same time, I was gathering more reference on *Star Wars*; collecting trading cards and movie magazines. And my interest continued to grow, especially when I heard about the production of a sequel.

When *The Empire Strikes Back* opened in May 1981, this time I didn't miss that first showing. It was not a disappointment. Looking back on the trilogy, *The Empire Strikes Back* is my favorite of the movies. The richness of the film's texture, and the increase in technical expertise really makes it stand out.

The special effects were much more refined, making everything look sharper and move quicker. Of course, the story was just as riveting and tight-paced as the first and the new imagery was just incredible. Who would have thought George Lucas could top *Star Wars*? But with the giant walkers, the space slug and Cloud City… Lucasfilm did outdo themselves.

In 1981 and 1982, with more new material coming out, I started to incorporate those images into new artwork based on *The Empire Strikes Back*. The piece featuring Luke and the scout walker *(pg. 11)* was a bit different for me. I wanted a lighter tone, so I used transparent and pastel colors, but I was still learning. I was trying to find my way in the paint, while developing a style of my own. The second piece I did during that period, a montage of the major characters' likenesses with all the pieces fitting together, was a large task for me.

I gathered what reference I could, and tried to design the piece to resemble a movie poster. Looking back on it, I think I achieved that effect fairly well, while beginning to get a handle on which direction I wanted to work. I was really excited when that piece was finished; it gave me a lot of confidence. I was, and still am, very happy with that painting.

Unfortunately, I sold most of those early paintings long ago while attending conventions. People had an interest in my artwork, and I was selling individual paintings for about $25 or $50. At that time, having no real job and needing exposure, selling the work was a pretty big deal. I got to know some buyers from attending cons regularly, but I haven't stayed in touch with them. That's why to my dismay there are no good reproductions of those early pieces available now, for this book.

In 1982 with the incredible popularity of *The Empire Strikes Back*, *Starlog* magazine and *Cinefantastique* began publishing *Star Wars* material and articles. *Cinefantastique* had been doing a lot of art covers, so I submitted some samples of my previous *Star Wars* artwork. Frederick Clark (owner/editor of the magazine) responded by saying he liked the material quite a bit. He also informed me his magazine was doing an issue on the making of *The Empire Strikes Back* and asked if I'd submit some cover samples.

At that time I had no published work, so I sat right down and did two watercolor roughs. One was just a plain front cover montage, the other a wrap-around montage featuring a number of different *The Empire Strikes Back* elements. I submitted the roughs without knowing (and they neglected to tell me) that the issue had been scrapped. Eventually, I took those pieces to a science fiction con in Washington and sold them to collectors. However, at that time, just knowing someone was interested in publishing my work was enough to get me excited. It was something early in my career that gave me confidence and kept me going, especially on the *Star Wars* material.

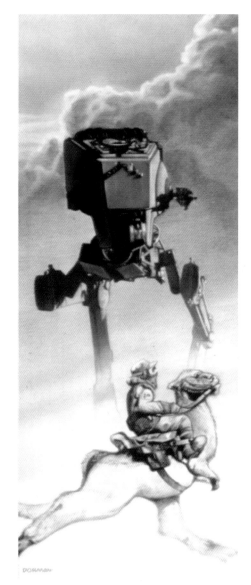

*An excellent example of Dave's increasing mastery of a medium.* The Empire Strikes Back *(1981) created as a sample for self-promotion.*

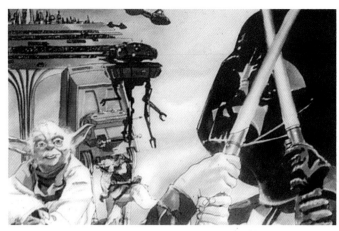

*A watercolor rough created as a sample for* Cinefantastique *in 1982.*

When *Return of The Jedi* was released in 1983, once again I was first in line at the theater. It was another summer filled with *Star Wars*. As usual, I tried to get my hands on as much material as I could, absorbing everything available. By this time, *Star Wars* had become a part of our culture. Following the success of the first two movies, the third film predictably skyrocketed. And there was new material everywhere; a real bonanza of reference. For me, it was very exciting to see all that new artwork being published, giving me hope for the future.

At that time, I finally had some work published with *Heavy Metal* magazine and Epic Comics and I was really beginning to diversify. However, I wasn't doing too much work featuring *Star Wars*, even though it was still influencing me artistically.

To me, the movie posters were very encouraging. At that time, Tommy Jung had completed his initial posters for *Star Wars* and *The Empire Strikes Back* and then the Hildebrandt brothers did their own version. There was also other art available. Production paintings by John Berkey and Ralph McQuarrie were being published. *The Art of Star Wars*, an art book which featured production illustrations, was on the shelves. To see how other artists interpreted or designed the movie elements, for me, was both a very educational and inspirational experience.

Between 1984 and 1989, I was off working in the comic and magazine fields producing fantasy and science fiction artwork. My interest in *Star Wars* was still high, but I was concentrating on establishing my own career. By necessity, I had to put creating *Star Wars* art on the back burner. As always, though, it continued to influence my work. Back then, Marvel Comics was publishing the *Star Wars* comics, which I was reading, and periodically I'd send them samples for cover consideration. Nothing ever happened and I didn't expect too much (at that time comics weren't using many painted covers), but it was gratifying to do the *Star Wars* samples. And, when the movies were first released on video tape, I rushed out to buy copies so

that I could watch the movies whenever the mood struck me. Which was often. Recently, when I finally purchased a laserdisc player, one of the first discs I bought was the *Star Wars* boxed set. Now, I can watch the widescreen versions as they are meant to be seen in all their glory. No matter how often I view them, the movies never fail to thrill me.

In 1987, a couple of creator-owned projects, Ron Randall's *Trekker* and Michael Gilbert's *Mr. Monster,* provided me with an opportunity to paint covers for Dark Horse Comics. Dark Horse was a new independent company that was interested in publishing innovative material and they were willing to try painted covers. It turned out to be very beneficial when Dark Horse arranged to do comics series based on licensed material. I was able to do work on Dark Horse's *Aliens* line, then covers for the *Indiana Jones and the Fate Of Atlantis* mini-series. That was the beginning of my relationship with Lucasfilm.

About that same time, I heard through the grapevine that Dark Horse was going to be publishing a mini-series based on the *Star Wars* universe but taking place after *Return of the Jedi.* This particular series *Stars Wars: Dark Empire* by creators Cam Kennedy and Tom Veitch had originally been scheduled for publication with another publisher but ended up with Dark Horse under license from Lucasfilm Ltd. I immediately approached publisher Mike Richardson and editor-in-chief Diana Schutz and inquired about the covers. The decision finally arrived, with Cam's approval, and I was given the chance to paint the covers. This was to be the beginning of a long and mutually rewarding relationship with Dark Horse Comics.

About that time, I was also able to arrange a license with Lucasfilm to produce and sell limited edition lithographs of my *Star Wars* art. My company, Rolling Thunder Graphics, produced the prints. Our first piece was the wrap-around cover from *Dark Empire* #1. It featured all the main movie characters and, due to its popularity with the fans, was an obvious choice for the first print. Our initial sales were excellent, and the print was

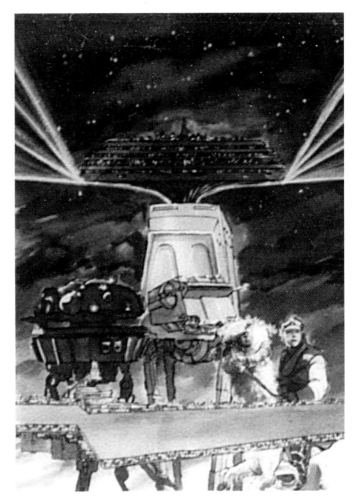

*Another watercolor rough created as a sample for* Cinefantastique *at the same time.*

13

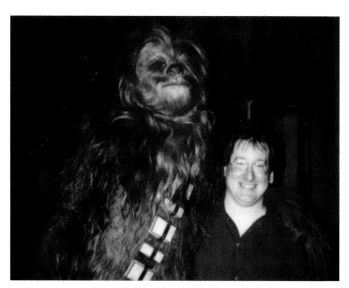

*(above) Dave and Chewie at Skywalker Ranch, Nov. 1994.*

*(below) Dave as Han Solo.*

sold out within three months of publication.

Through the course of the *Dark Empire* series, I started to notice a renewed interest in *Star Wars*. There had been a lull since the releases of *Return of the Jedi* and the Timothy Zahn *Star Wars* novels, but the *Dark Empire* series seemed to have rekindled some of that prior excitement. It felt good to be part of the revitalized interest in the *Star Wars* universe which I had always loved. To have my work followed by so many older fans, plus all the new fans who were seeing the *Star Wars* films on videotape and TV for the first time, was gratifying. In addition, the series really helped Dark Horse establish itself as a quality publisher and a force in comics. Their use of painted covers spurred the use of painted cover art in other branches of the comics field.

So, when Dark Horse Comics contacted me to do covers for a new series, *Dark Empire II*, I eagerly agreed. It was also a pleasure to learn that Cam Kennedy and Tom Veitch were both returning to work on this new series. I felt that our combination couldn't miss. And it didn't. We produced another series of six books that was just as exciting as the first one. My feelings about this new series remained unchanged; it was just as thrilling to be continuing doing *Star Wars* art then as when I had originally began on *Dark Empire*.

At this point, the popularity of Dark Horse's comics were becoming more obvious as foreign editions of the books began to appear. *Dark Empire* was being published in England by Dark Horse UK, and then other foreign editions of the compilations started to come out. Then, I knew for sure that I was working on a very popular item.

After *Dark Empire*, the interest in *Star Wars* seemed to really explode. Topps published a *Star Wars Galaxy* card set, featuring a variety of comic and science fiction artists doing new single *Star Wars* pieces. I did one card, "Droids only," for that first series. That set excited the card collector's market, and subsequently, Topps has produced two more sets of *Star Wars Galaxy* cards.

With the success of *Dark Empire*, Dark Horse

Comics followed up with more *Star Wars* adventures. *Tales of the Jedi, The Freedon Nadd Uprising, Empire's End* and *X-Wing: Rogue Squadron* were just a few of the other projects I was delighted to work on.

During my work on *Tales of the Jedi*, Berkley Books approached me to do covers for a book series called Young Jedi Knights, written by Kevin J. Anderson and Rebecca Moesta. Kevin had suggested that I paint the covers, and Lucasfilm agreed. After the first cover was completed, Berkley decided they wanted foil etching on the books for a more distinctive appearance on the bookstand. As a result, the initial painting I did for the first book had to be slightly altered to accommodate an edge for the foil. This is why there are two versions for each cover (except #2, which had no foil). Here, you will see the original art for the very first time. The books have sold well with the help of the foil embellishment, but for this artist it's always nice to see his work unencumbered by type or enhancements. Another five book covers are scheduled for future release.

In November 1994, I was able to experience *Star Wars* as never before. Lucasfilm held a summit for license holders. As owner of Rolling Thunder Graphics, I was invited to attend. It was exciting to have the opportunity to go to the Skywalker Ranch – this mystical enclave of creativity. I felt fortunate to hold a license for the prints, and even more fortunate to be invited to the summit. From a business standpoint, it gave me an opportunity to meet some of the other company reps who had been using my artwork for licensed product; like Antioch, Metallic Impressions and Galoob. It also gave me a chance to forge new relationships with companies that in the past might not have thought of using my artwork. Personally the summit provided me with a chance to go through Lucasfilm's reference library, expanding my access to a number of photos. After over 15 years of enjoying *Star Wars*, it was one of the best combinations of work and pleasure I could imagine.

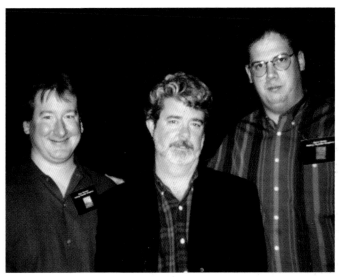

*(above, left to right) Dave with George Lucas and Steve Smith.*

*(below) Dave with Lucasfilm's Kathleen Scanlon and the real Boba Fett helmet!*

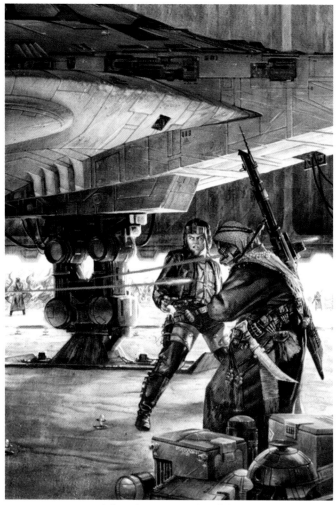

*(above) An example of the many* Star Wars-*influenced works Dave has created at art directors' requests. This is from a game produced in 1991.*

*(below) A parody Dave did for his friend Greg Hyland's comic book featuring Greg's character, Lethargic Lad as Dark Lad.*

Lucasfilm had organized a lot of activities to keep everything interesting for the two-day summit. We previewed new, digitized Jabba the Hutt footage for the release of the *Star Wars Special Edition*. We visited the prop and costume warehouse. At the THX soundstage, authentically costumed figures mingled with the licensee guests at a dinner set like the movie's cantina sequence. Various licensees where there to offer special promos, including digitized photos starring you as your favorite *Star Wars* character (see page 14).

However, the most exciting aspect of the summit, and the biggest surprise, was meeting George Lucas. At the end of the second day, he came out and thanked all the licensees. I hadn't anticipated him staying for any length of time, but to my surprise, afterward he mingled with the crowd. I built up my nerve, and with some encouragement from Steve Smith, went up to say hello. I introduced myself, told him how much I enjoyed the movies, and how privileged I felt producing new artwork based on his creations.

Then George told me that he enjoyed my work. This was a real career high point. The fact that he was even aware of my work was a real compliment. The memory of that moment keeps me working to produce the best *Star Wars* art I can. It was a once-in-a-lifetime experience.

I am now continuing my *Star Wars* art with the Young Jedi Knights book series and through Rolling Thunder prints. My company has successfully negotiated with Lucasfilm to increase the amount of new *Star Wars* material we are able to produce. Boba Fett was the subject of our first of these new prints. Although based on the *Dark Empire II #2* cover, the figure is all that remains of the original. I had wanted to do original pieces of Obi-Wan Kenobi and Darth Vader and happily they were included in the new, broader licensing agreement. So far, these character pieces have proven to be extraordinarily popular, selling out shortly after publication. I have more of these pieces planned for the future.

The influence of *Star Wars* is unquestionable, both in our culture and in the field of science

fiction art. Since the first film came out in 1977, the public's view of science fiction has really changed. It's not uncommon for an art director or editor to now request a "*Star Wars*-like" piece. To become "*Star Wars*-like," has become a part of the art vernacular; describing a particular look. I've even been involved in these kinds of projects myself.

*Star Wars* has become a significant part of our popular culture. The way things are done in the film and print industry has changed because of that influence. It's difficult to pinpoint just what elements of the films have made an impact, but it is unmistakable all the same. For me, as an artist, the mark *Star Wars* has made is indelible. Never does a workday pass when the *Star Wars* look doesn't influence or affect my work. I hope that in the years to come I will continue to be involved with *Star Wars*. I dream someday of working on the movies, whether in preproduction illustration or poster design. With the new movie series being produced, I have hope that someday that dream will be realized. I delight in doing my *Star Wars* art. The characters are consistently interesting and entertaining to paint. To take a new artistic tact with something that is so well-established is an awesome challenge.

Whatever happens, as long as the fans continue to enjoy my work, and I keep getting joy from what I do, then I'll continue to put my heart into creating art for *Star Wars*."

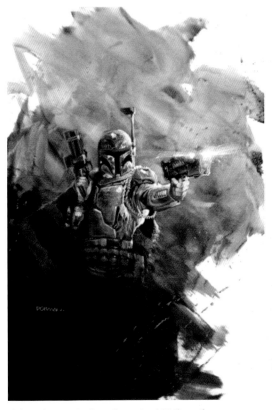

*(above) A painting done in 1995 at the San Diego Comic Convention. This was created in just a few hours by Dave, painting in front of an enthusiastic crowd.*

# The Comic Books

*All of the images contained in the "gallery" section which follows were created for Dark Horse Comics, as covers for their diverse* Star Wars *comic book line. Beginning in 1990 with* Dark Empire, *Dave's covers have shown* Star Wars *fans many highs and lows in the lives of Luke Skywalker, Princess Leia, Han Solo and the rest of the good guys, while also giving life to many new characters, including the ancient Jedi warrior, Nomi Sunrider from* Tales of the Jedi. — *The Editors*

"For my first cover assignment, Dark Horse Comics requested a movie-poster style painting reminiscent of older pieces, which was to establish the role all the characters in the comics. My cover then was heavily influenced by previous *Star Wars* art. I looked at production illustrations, the Drew Struzan pieces and the Ralph McQuarrie artwork. This was the kind of look I was trying to achieve with the cover, I wanted to get the feel of the films.

In *Dark Empire II*, I wanted to change the feel of the covers to better portray the action. The only montage scene done for the *Dark Empire II* covers was for issue #4. The face-off between Han Solo and Boba Fett had to be done as a montage because I wanted to put both the characters and their ships in that particular piece. I think it worked very well.

When *Dark Empire* was completed, Tom Veitch came up with the idea of defining the background surrounding the establishment of the Jedi Knights. He proposed a comic series called *Tales of the Jedi*, which looked back on Jedi Knights four thousand years before the films took place. The initial series ran over five issues, introducing a whole new set of characters, including Ulic Qel-Droma and Nomi Sunrider. These are main characters whose stories are continued through other Dark Horse series. Also, I was involved in a two-issue series that tied up the loose ends of *Tales of the Jedi;* called *The Freedon Nadd Uprising.*

Following *Freedon Nadd*, came *Empire's End*, a two-issue finale to the *DE II* series. I continued to try and create interesting images featuring the characters.

The *X-Wing: Rogue Squadron* project came about following *Empire's End*. The series followed Wedge Antilles, from the *Star Wars* movies, who becomes the Rogue Squadron leader.

What follows are my paintings for these comics and the many alternate illustrations that have never been seen before. Enjoy."

—*Dave Dorman*

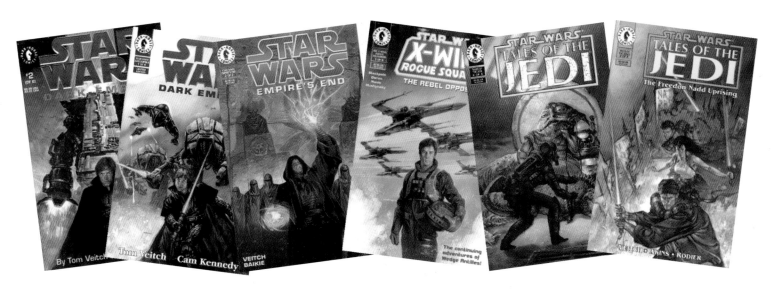

## DARK EMPIRE #1

"Each of the covers for the *DE* series utilized elements from within that particular issue. I experimented with the color bar element and a montage that would communicate a feel for what each issue was about without giving away too much. The purpose of this piece was to reestablish the main film characters as integral elements of the *Dark Empire* story in a montage movie-poster format. This was my first attempt, professionally, at doing a montage piece, though one of my earliest *Star Wars* pieces was a movie poster-style montage *(pg.10)*."

*(above left) A series of progressive roughs.*
*(above right) A tight layout of the cover.*
*(left) A tight pencil drawing of R2-D2 Dave used on the cover.*

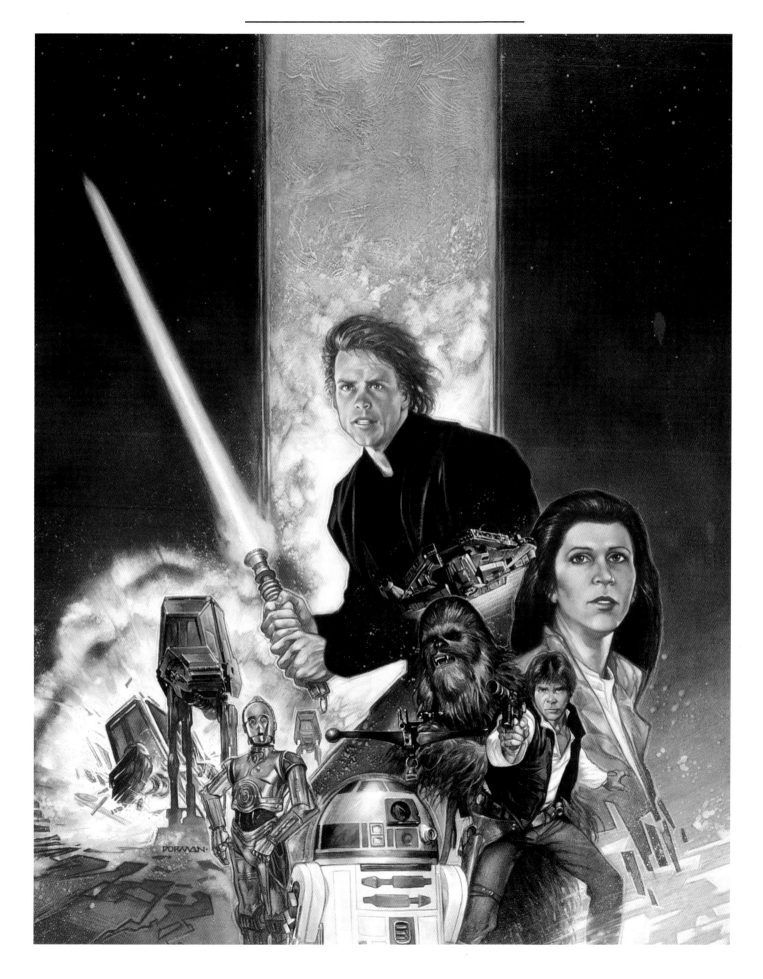

## DARK EMPIRE #2

"Dark Luke. This piece marked the beginning of Luke's seduction by the dark side of the Force. I tried to show this by darkening most of his face, leaving only his eyes in the light. He is also dressed in a dark Jedi suit, much like Darth Vader's. The World Devastator behind Luke symbolizes the Empire's attempts at creating larger, more powerful machines of destruction."

*(above) A tight pen drawing of the final layout.*

*(right) A British trade edition of the six-issue* Dark Empire *series incorporating this image as its cover.*

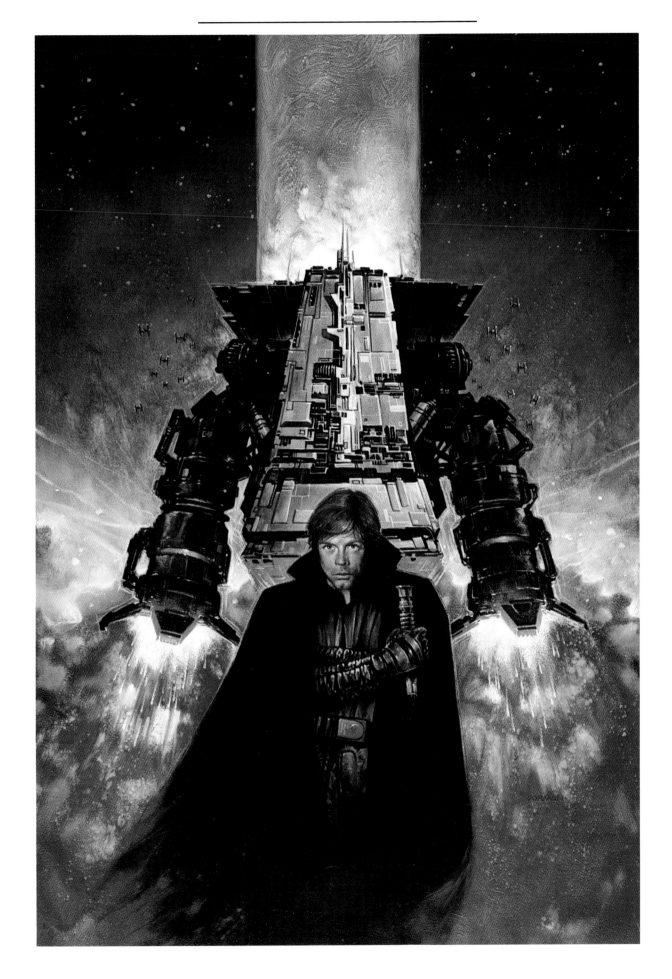

## DARK EMPIRE #3

"This cover was problematic because the story wasn't very action-oriented. I tried to pull imagery that I felt was most dramatic; Darth Vader's ghost appearing to tempt Luke to the dark side, followed by Luke's ghost appearing to torment Princess Leia. She faints from the shock of Luke being seduced by the dark side.

My original rough featured the shadow of Darth Vader but Lucasfilm said they didn't want Darth Vader to be used at all, so I adapted the layout to show Luke instead."

*(above left) A rough of the final cover.*

*(above right) Dave's original layout with Darth Vader's spirit haunting Leia.*

*(left) The British comic series reprinted all of the covers sequentially. These were magazine format with additional non-Dark Empire material included in every issue.*

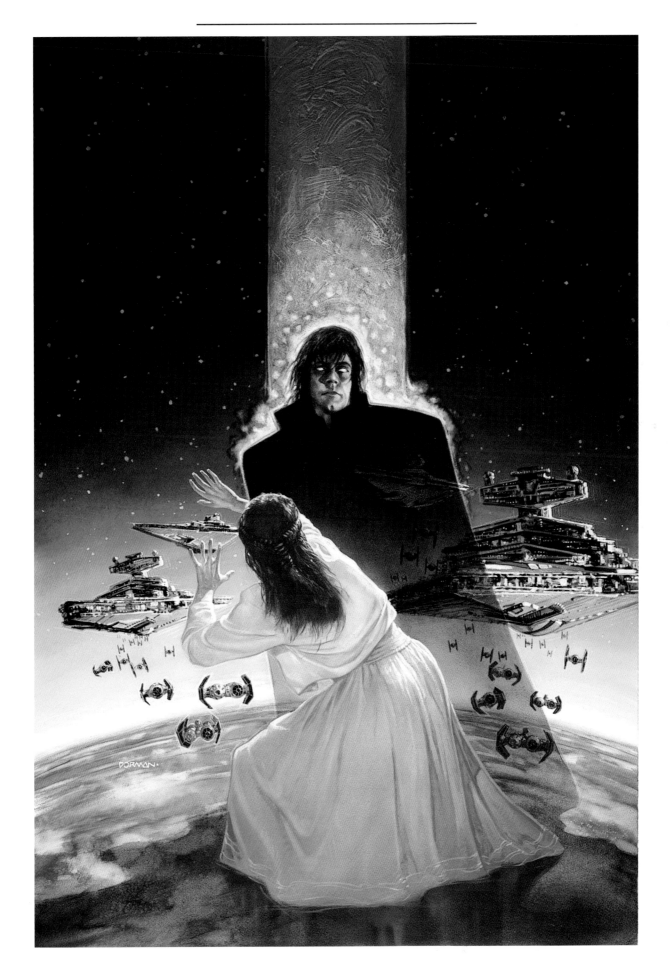

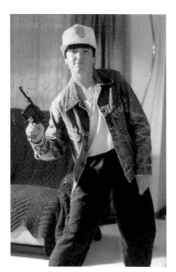

## DARK EMPIRE #4

"This was a fun opportunity to do an action scene with Han Solo being chased by Boba Fett in a big showdown. It was my first opportunity to do Boba Fett in painted form and I really enjoyed it. Fans at conventions agreed. I got a great deal of compliments on this cover. So many, in fact, that it was made into a print through my company, Rolling Thunder.

It was a smart move on Tom Veitch's part to bring Boba Fett into the story as one of the antagonists. It had a great deal to do with the resurgence in the popularity of that character."

*(above left) Along with rough sketches of Leia and the group of bounty hunters, are photos of Dave's models for this project. Phil Burnett as Boba Fett (he also posed for the body of Han Solo), and Dave's wife, Lurene, as Leia.*

*(above right) A pencil rough of the final layout.*

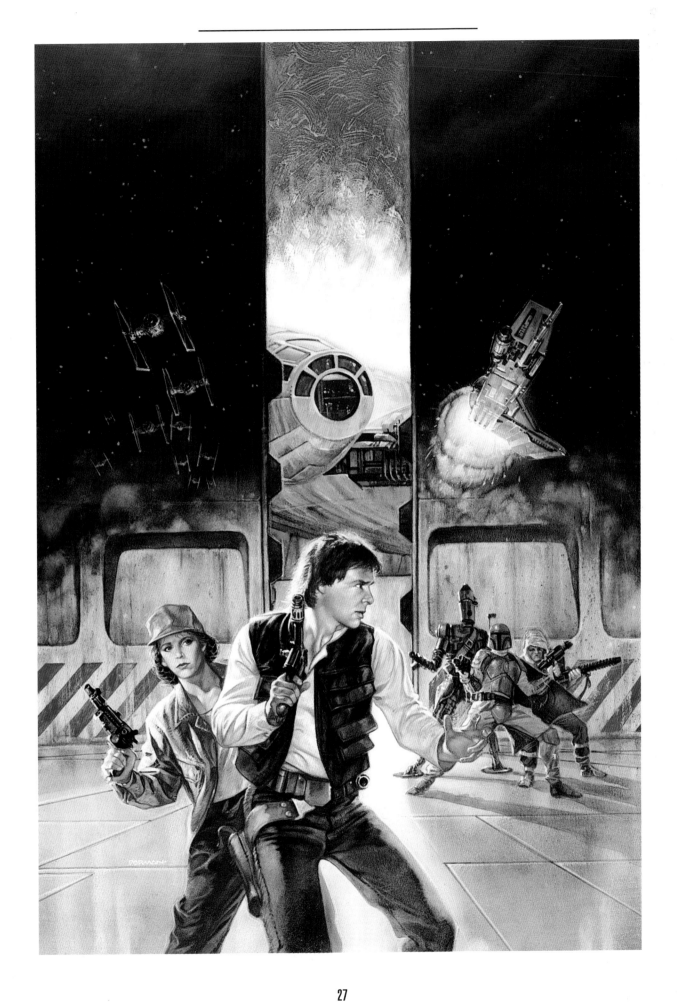

## DARK EMPIRE #5

"I focused on the story's turning point, when it is disclosed that the Emperor had been cloning himself and that he had a chamber of clones. I did a montage of the old Emperor and the clone chambers, with one of the clones actually awakening to be the new Emperor. Of the six covers, this was one of my favorites."

*(above left) A preliminary rough without the old Emperor.*

*(above right) A different rough with the old Emperor.*

*(left) A photo of model Phil Burnett.*

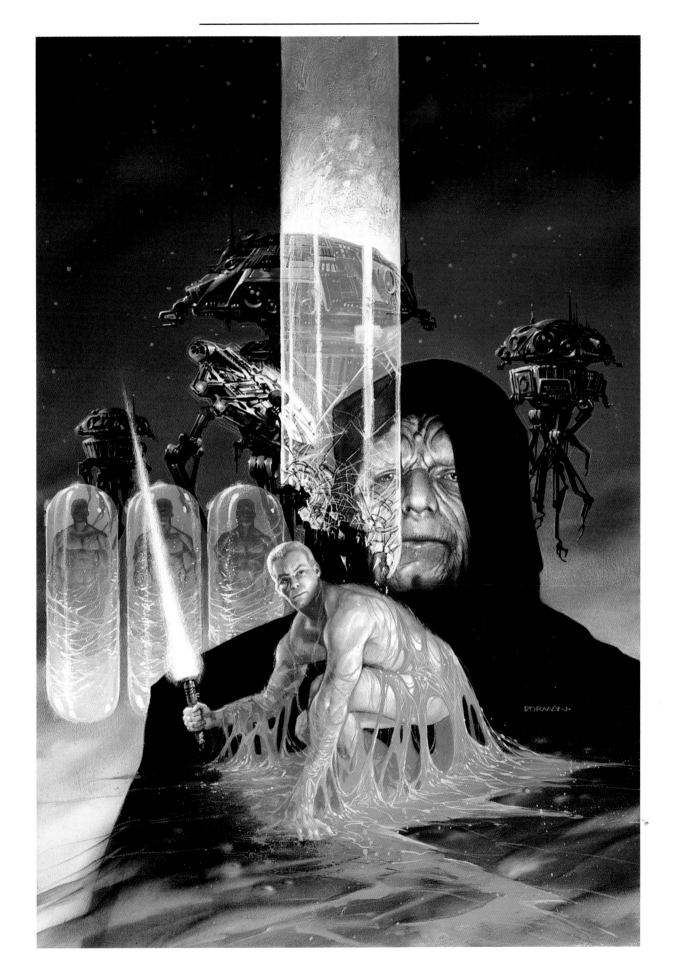

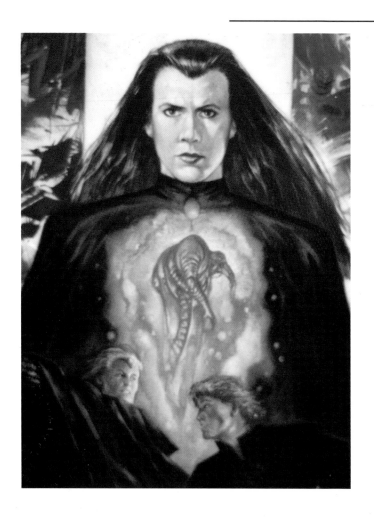

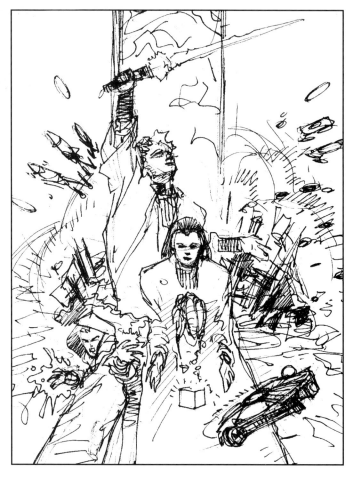

## DARK EMPIRE #6

"This was the bookend to the series where I wanted to show Leia's movement upward into Jedi Knighthood. The background images are from various covers. The Empire's World Devastator from #2 is being destroyed. The main image of Leia serves to counterbalance Luke from #1.

One interesting note on this cover is that in my original painting, I had the Jedi Master Bodo Baas from the Holocron cube placed in front of Leia. But the editors thought it looked too much like a chest-burster alien, so I painted it out and added Leia's hands and her lightsaber."

*(above left) A detail from the original painting featuring the Jedi Bodo Baas.*

*(above right) An early layout featuring a more action-oriented design. Note: Bodo Baas is still in front of Leia's chest.*

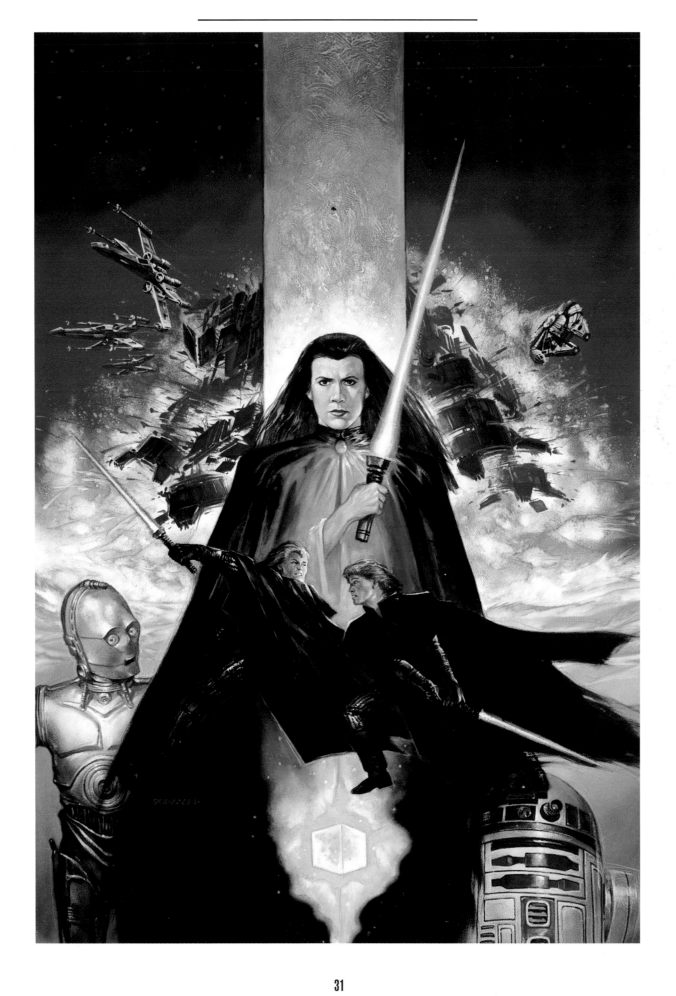

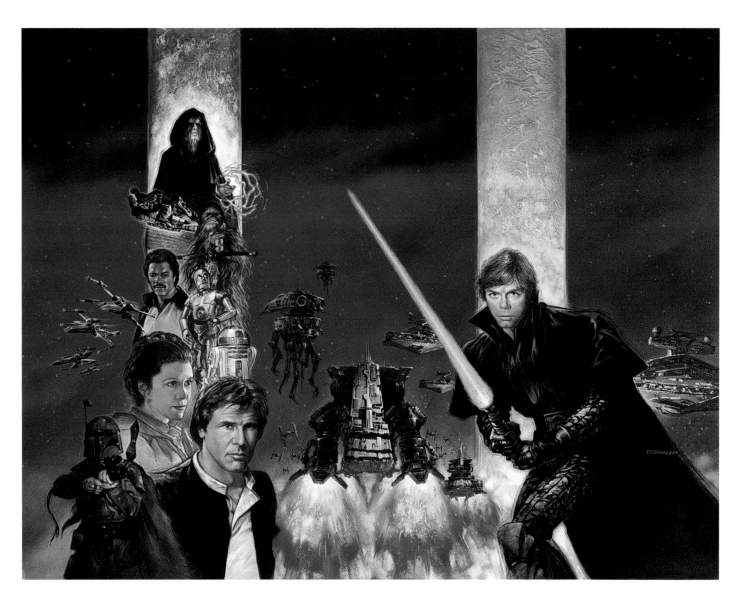

## DARK EMPIRE
## TRADE PAPERBACK COLLECTION

"After the initial *Dark Empire* series, the comics were collected in a trade paperback version with a new cover. In this particular piece, I tried to compose a montage of all the key elements from the stories. The series has since been reprinted in foreign editions and this art has been used on the front of a calendar, among other items."

*(left) A pencil detail of the original Luke face which was later changed. An example of computer-altered art. The same painting cropped and modified for a Time-Warneraudiobook package.*
*(pp. 34-35) A centerspread of the image pictured above.*

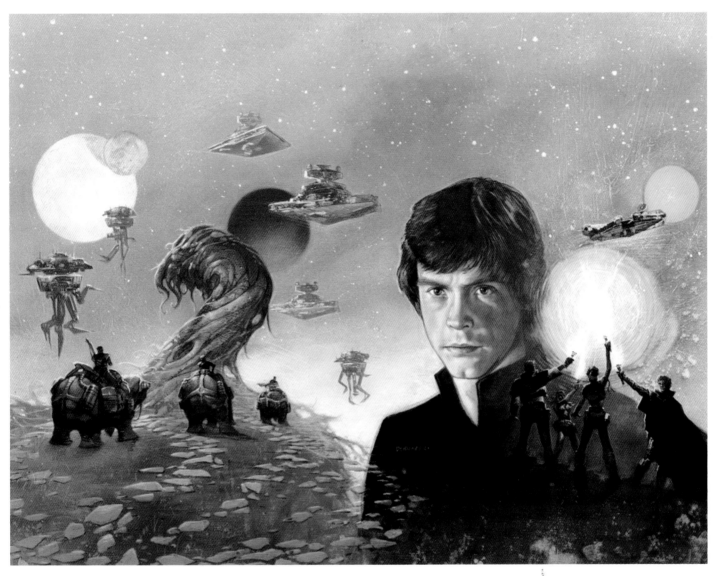

## DARK EMPIRE II
## TRADE PAPERBACK COLLECTION

"It was decided, editorially, that the wrap-around cover
for the collected version of *Dark Empire II* should have
a completely different look than the cover to the first series.
We chose to do a montage of a large head of Luke looming over
the four Jedi heroes who were the main characters in this storyline.
Color-wise, I stayed in a naturalistic, pastel color range.
It worked well. Cam Kennedy's interiors had a great influence
on how I rendered the four Jedi."

*(right) Dave's rough for the four Jedi Knights. Though loose, Dave stuck
very true to this design, using lighting to define the figures.
(pp. 36-37) A centerspread of the image pictured above.*

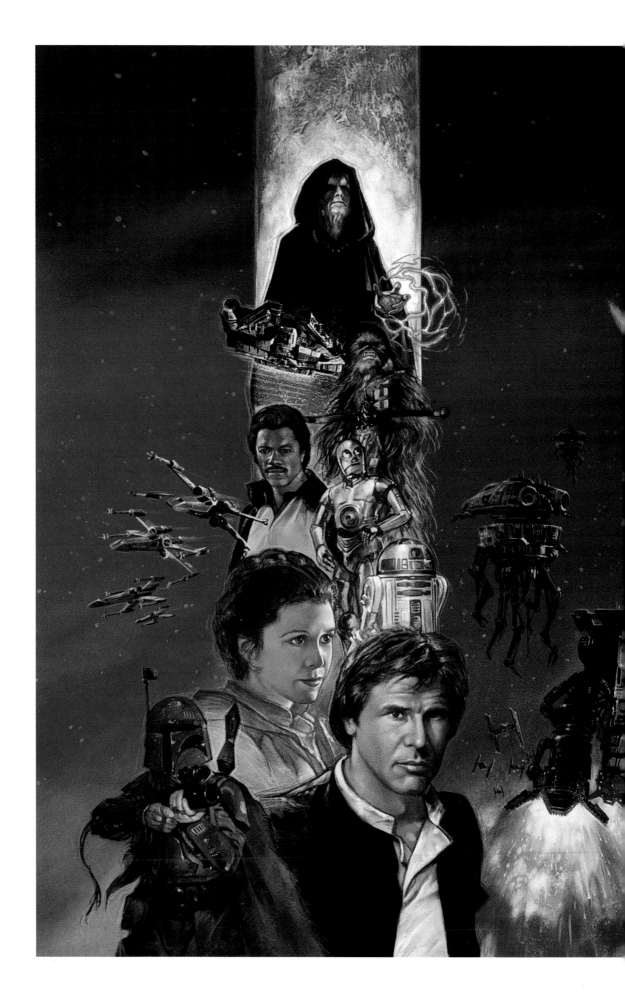

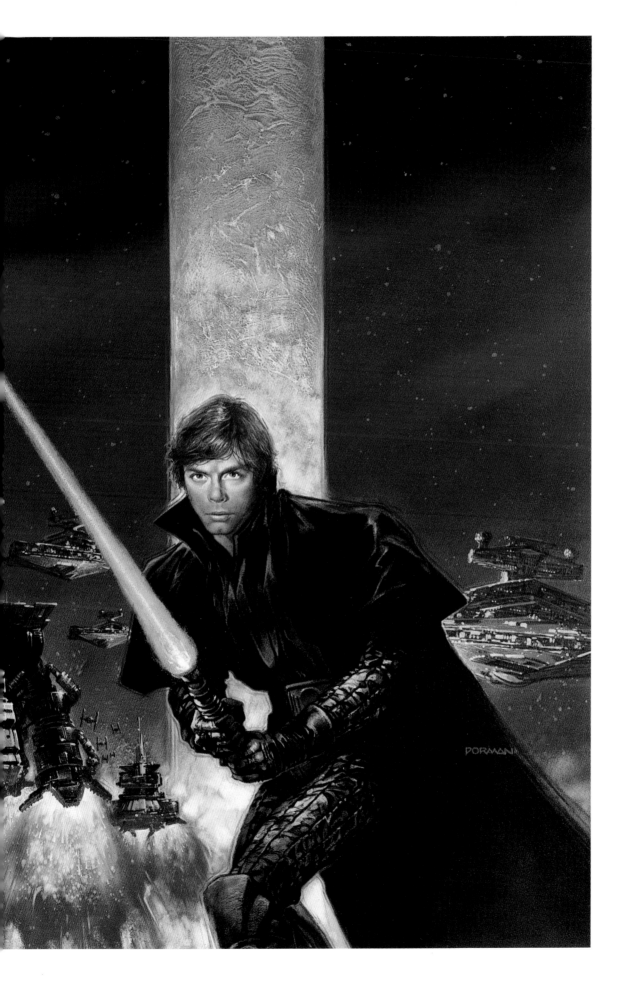

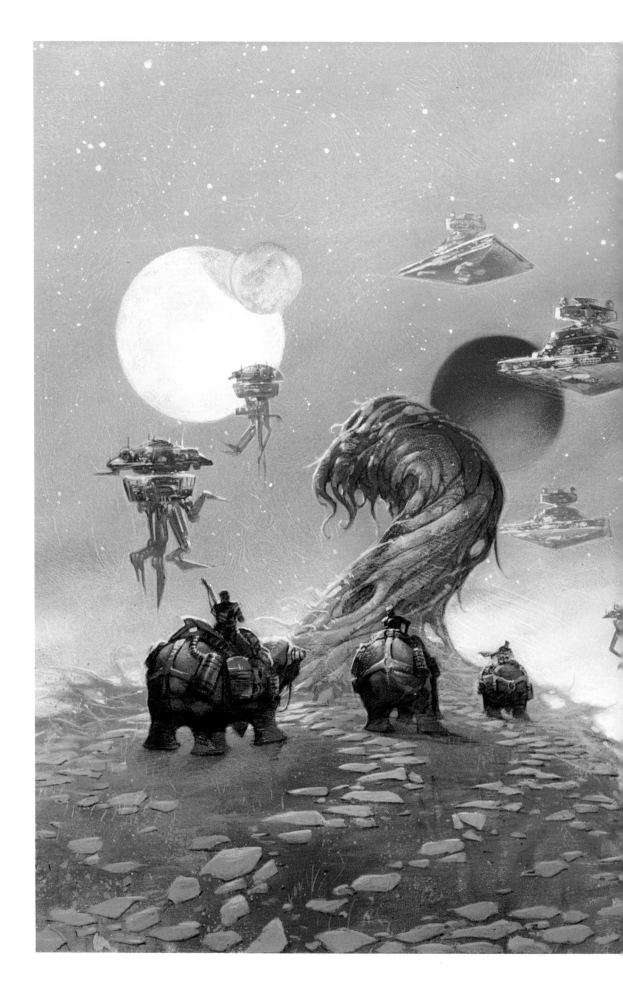

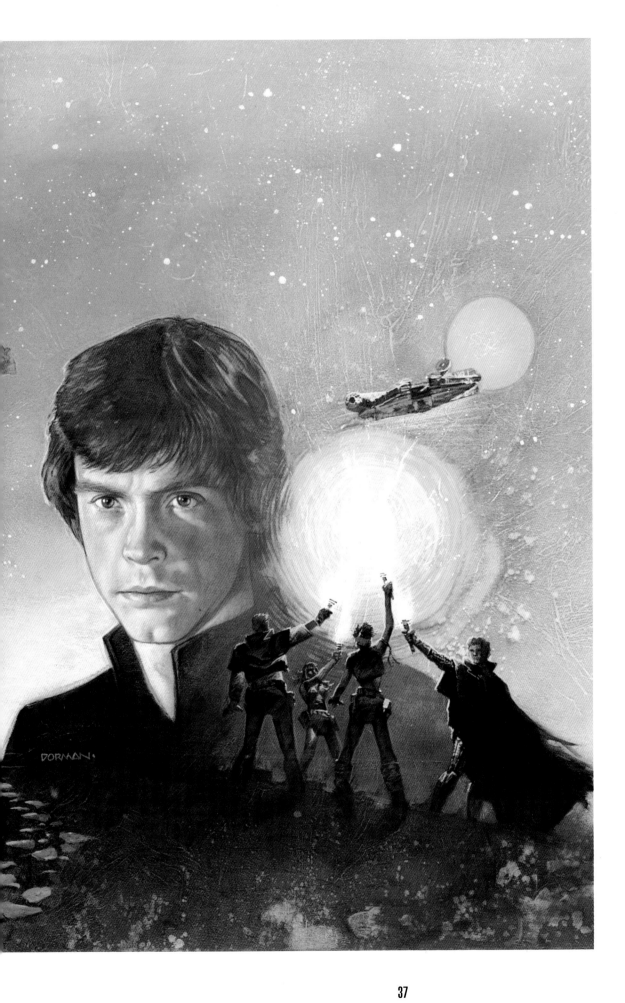

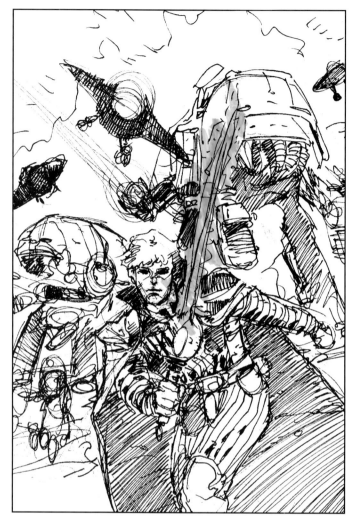

## DARK EMPIRE II #1

"Since it had already been established that the original movie characters had come back in *Dark Empire I*, the decision was made to go with more action-oriented covers, moving away from the montages. This is an action montage scene! Luke is reestablished as a Jedi, wearing his full-fledged Jedi outfit and shown in a Darth Vader-style suit to remind himself of his temptation from the previous story. Luke is shown here in front of new war machines created by the Empire but captured by the Alliance. I don't feel I'm very good at painting mechanical things but I'm pleased with how these turned out."

*(above right and left) Two stages of roughs. The loose doodle and a more defined loose rough.*

*(left) A tight drawing of one of the Imperial war machines and the final art as used in an audiobook package.*

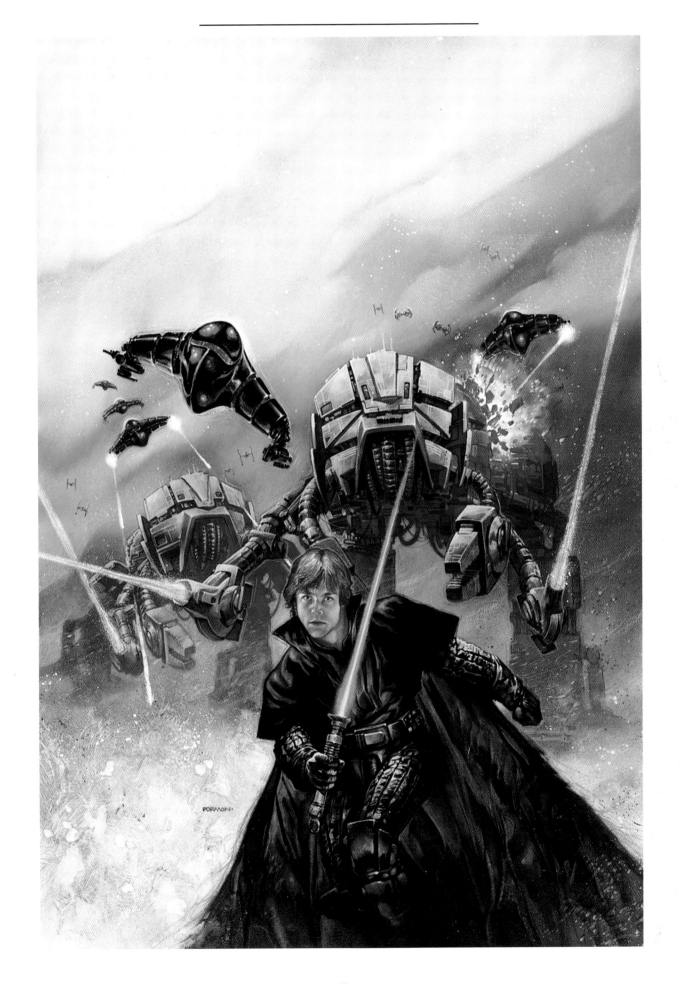

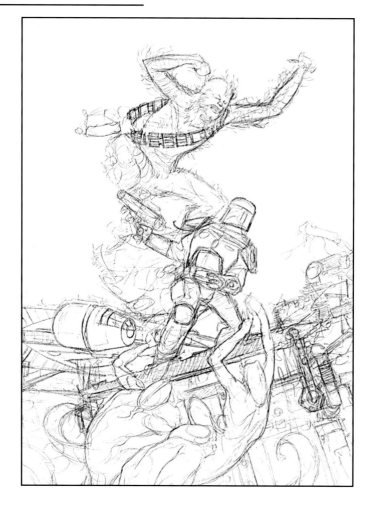

DARK EMPIRE II #2 (Alternate Cover)

"In *Dark Empire II*, Boba Fett is back and pursuing Han and Chewie. In this chapter, they are on a strange planet where Han is being chased by Boba Fett, while Chewie splits off to circle around and sneak up behind him. I thought this would be effective because Chewie is rarely shown in a heroic stance. Usually, he is just seen as a big furball. Here, he is in a action pose. I did this design to show Boba Fett being attacked by the sewer creatures from below and Chewie from above. I liked this piece for its action, but the editors changed their minds and told me they wanted Boba Fett featured as the main character. This is the first time this piece has been published.

*(above) A tight pencil drawing of what would become the final painting.*

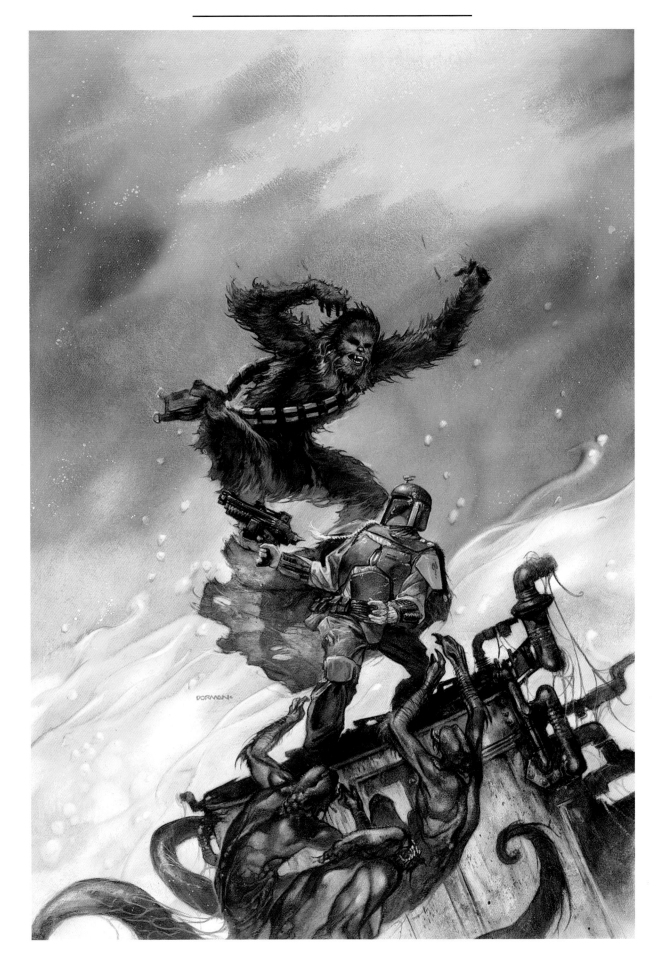

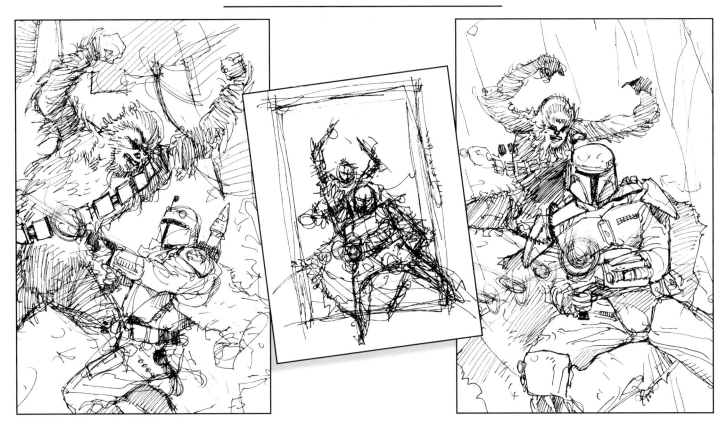

## DARK EMPIRE II #2

"This, the second version, was the actual finished cover. It featured Boba Fett in all his bounty hunter glory, shooting at the readers as if they were Han Solo, not knowing that Chewie is about to pounce on him and turn his helmet into pulp. This is exactly what editorial wanted and that's what I gave them. It did, admittedly, turn out very well. It was a very popular cover."

*(Above left to right) A variation of the first painting progressing toward the final image. The middle piece is a loose rough with the characters closer to their final position. The piece on the right is a tight rough of the final painting.*

*(Left) Del Stone, Jr., a friend of Dave's, poses as Boba Fett.*

*(right) A British edition from Boxtree Books, collecting all of the* Dark Empire II *comics into one volume.*

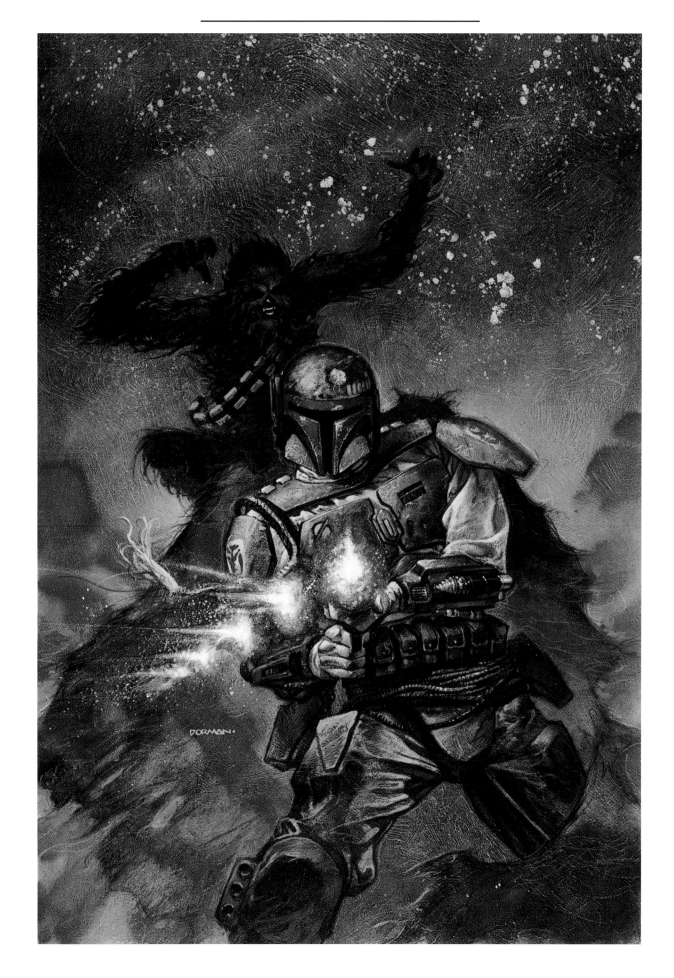

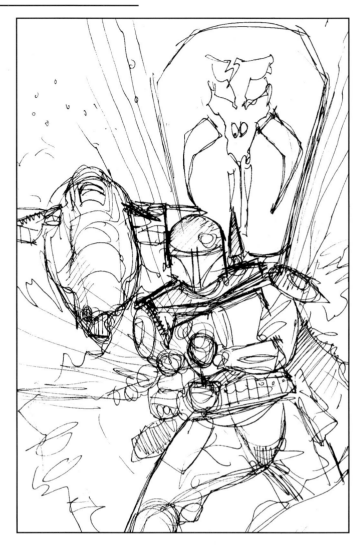

## BOBA FETT ART PRINT

"Because of the popularity of Boba Fett and a tremendous response to the comic book cover, I decided to redo the *DE II* #2 piece as a limited edition print through Rolling Thunder Graphics. In the painting, I wanted to concentrate on Boba Fett instead and not tie into the *Dark Empire* comics. So, I decided to rearrange elements. I took out Chewie and added *Slave I*. I also utilized Boba Fett's shoulder emblem as a large graphic element. This edition sold out very quickly."

*(top left) The background layout for the print without Chewbacca featured.*

*(middle left) The color comp produced in Photoshop for sales solicitations before the painting was created.*

*(above) The rough for the revised painting.*

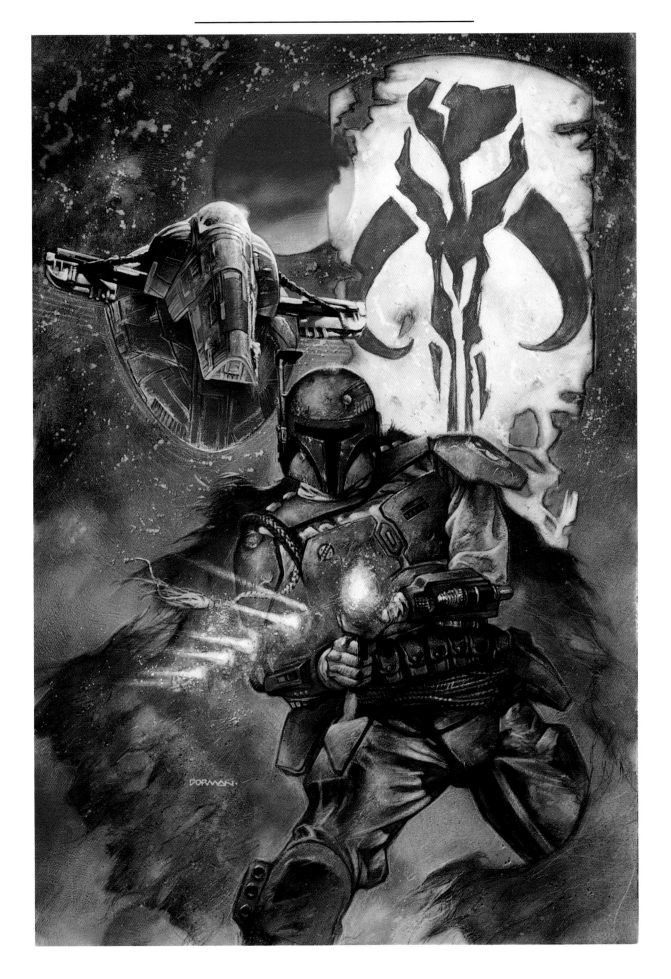

## DARK EMPIRE II #3

"This piece was an extremely difficult one for me to do. I had to fit in the tree holding the female Jedi, plus Luke and his other Jedi companions.
The editors wanted all of these elements to be composed within one action-oriented painting.
If there's any one painting in this series I think I failed on, it is this one. However, many fans have told me they like it. Maybe I'm too critical of my work, but I don't think this one was well-executed."

*(top left and left) A rough doodle of a possible composition, and a very elegant figure rough of the female Jedi trapped by the tree.*

*(above) An alternate layout featuring a much more dynamic approach, rejected by editors.*

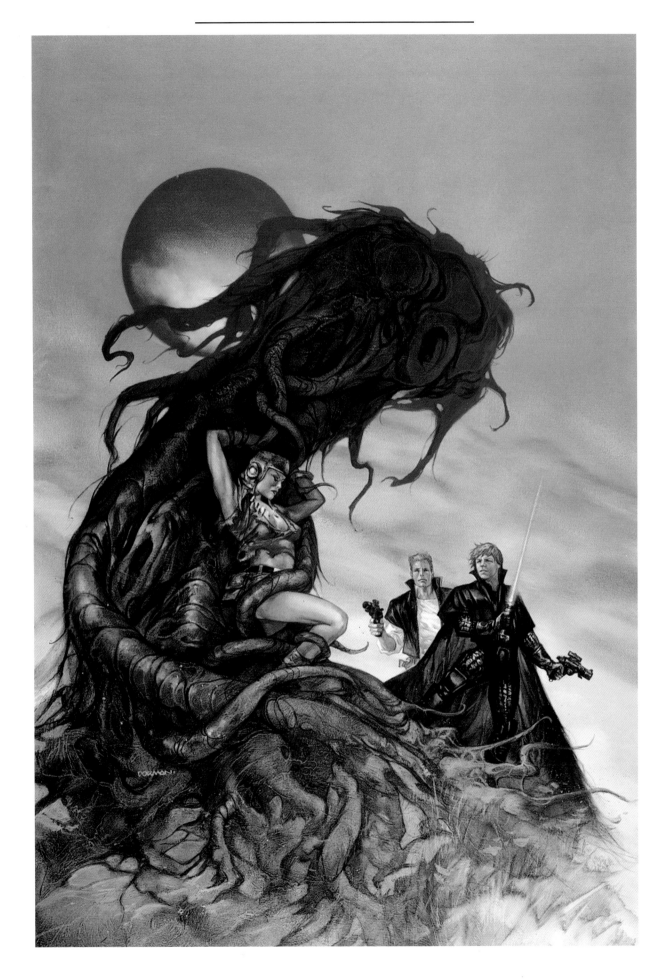

## DARK EMPIRE II #4

"This was done as a piece to appease the fans. Everyone wanted a face-off between Han and Boba Fett, and that's exactly what I gave them. Not only did I include the two characters, but also their two ships battling in the background. It was a fun piece to paint; these are two of my favorite characters and their ships are two that I can paint fairly well."

*(above) A rough layout of the final piece.*

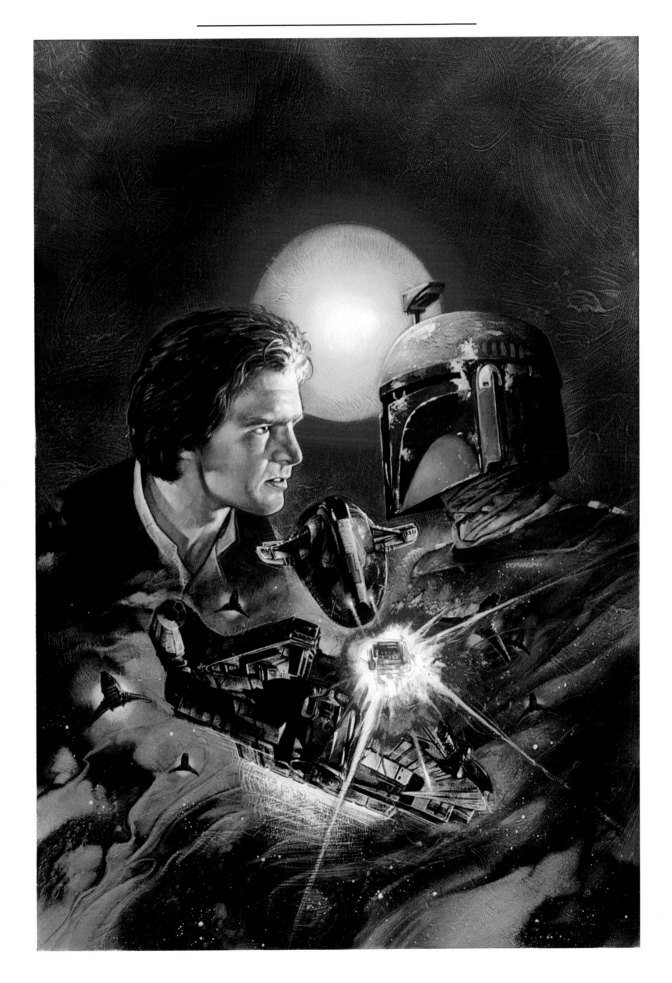

## DARK EMPIRE II #5

"This was a fun piece because it featured Lando. He is a popular character but is not often featured in action by himself. He is seen almost exclusively with the main characters. This was a great scene to do and I especially like to draw the droids."

*(top left) A preliminary rough featuring Lando and the droids on a rock bridge, collapsing from the weight of the rancor monster.*

*(left) A tight pen rough for approvals.*

*(above) A tight pencil detail of Lando's face.*

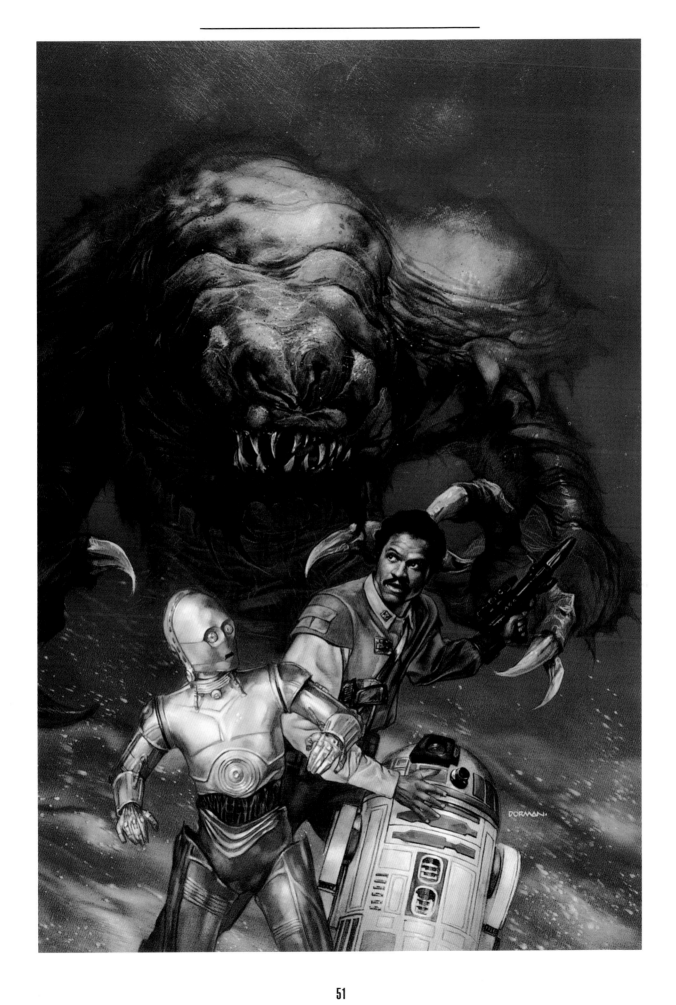

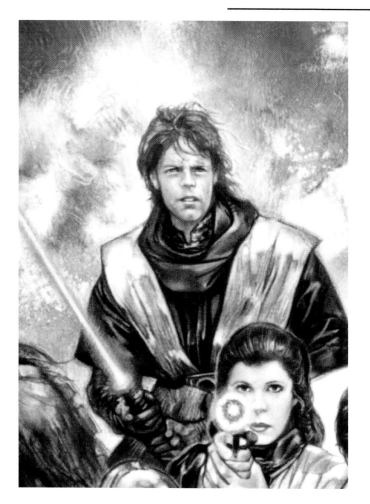

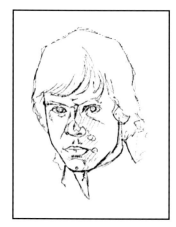

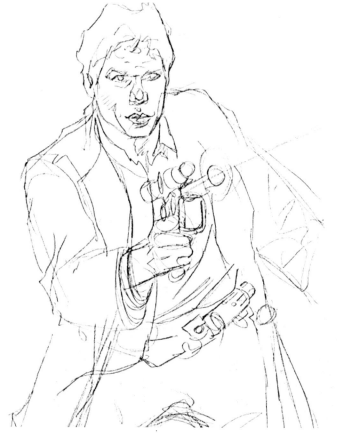

## DARK EMPIRE II #6

"This was the big battle issue and I wanted to bring all of the characters together, but in a group shot instead of a montage. What I did was grouped them as our heroes fighting for their lives against... you, the reader! Once again, this has become a very popular fan piece because it includes all the characters.

I did have a slight problem with this piece since the reference I had of Luke, which I thought was good (sort of squinting for more of an action-look) was rejected and I had to repaint his face to be a little more "recognizable."

*(top left) The original painted version of Luke's face, with some slight differences in Leia's face as well.*

*(top) The pencil drawings of the two different Luke heads.*

*(middle) Figure action pose doodles for this piece.*

*(left) Tight pencil drawing of Han Solo used for this painting.*

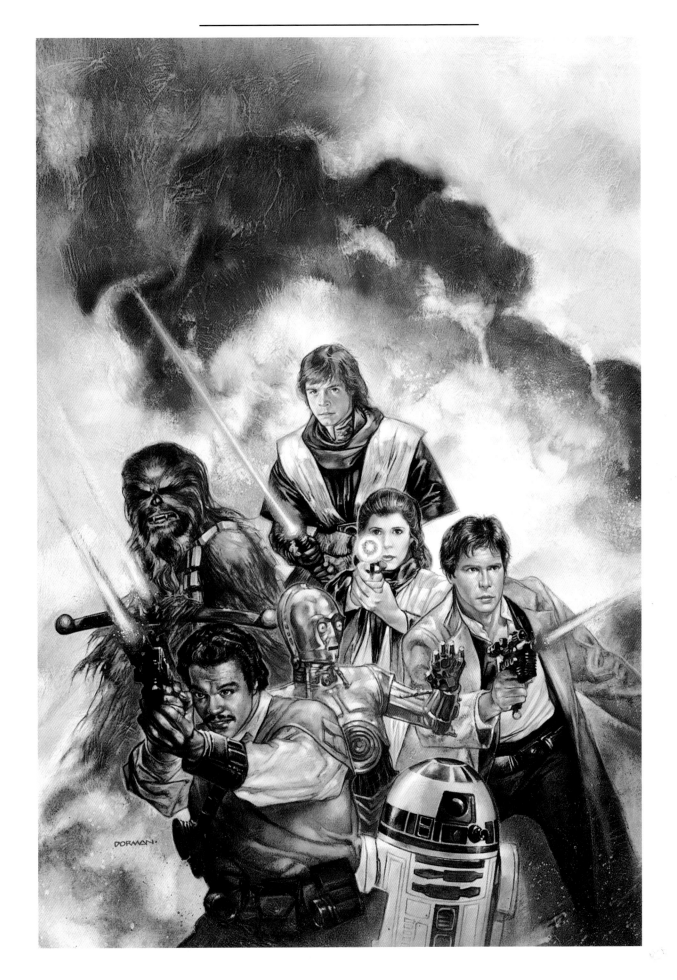

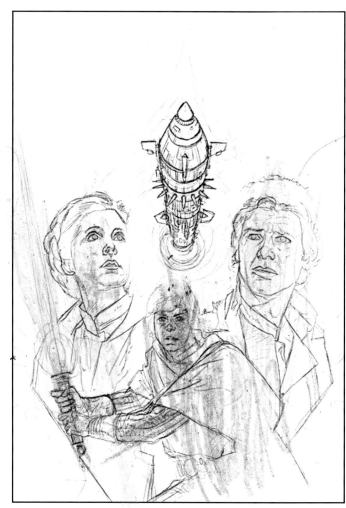

## EMPIRE'S END #1

"Once again, the Empire is back with bigger machines of destruction. I wanted to show that the heroes were also back, this time fighting a new bunch of foes. This piece is fairly straight-forward."

*(top and middle left) Progressive figure poses.*

*(above) A tight pencil drawing of the cover art.*

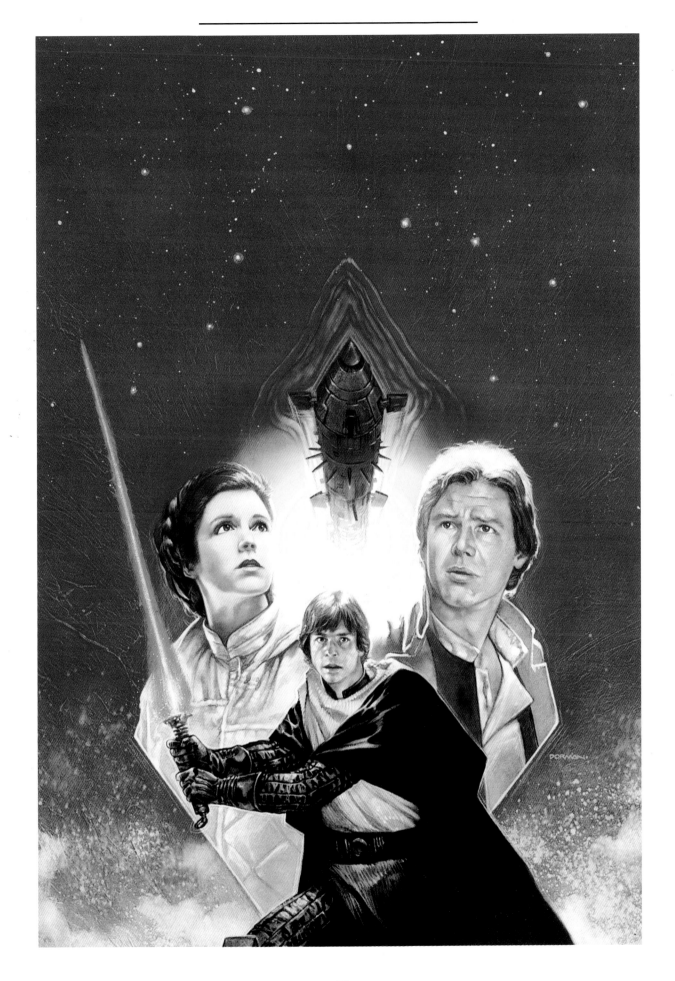

## EMPIRE'S END #2

"In the story, the Emperor was very angry. I wanted to portray him showing his frustration as he went to the temple of the old Masters to try and soak in their aura… their Jedi Force. Out of frustration for his apparent failure, he raged at the thought of being foiled once again by Luke and his companions."

*(above left) Detail of the Emperor's face in a diabolical grimace, drawn as part of the pen rough sent for approvals.*

*(above) A pencil drawing of the final piece, ready for painting. The background clearly shows the cave painting which was, unfortunately, obscured by the logo and cover type.*

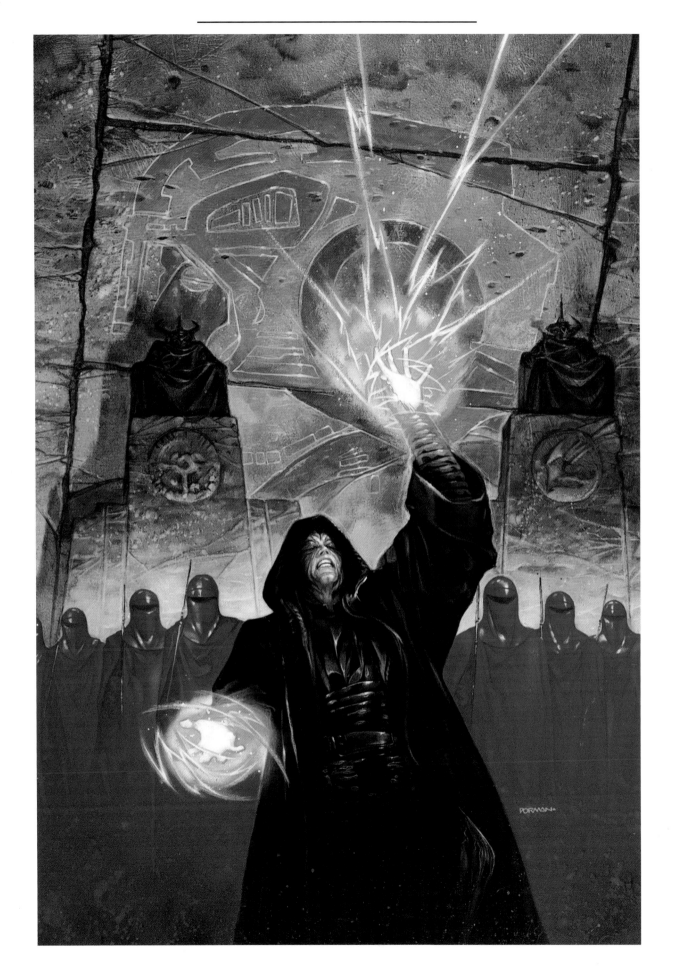

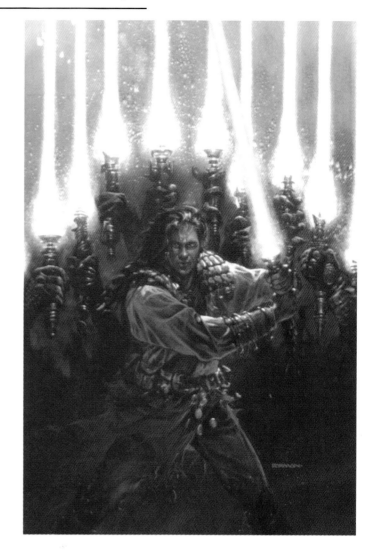

## TALES OF THE JEDI #1

"It was Tom Veitch's idea to look into the history of the Jedi Knights. He proposed a series called *Tales of the Jedi*, which focused on Jedi Knights four thousand years before the time set in the films. While painting, it was fun not to have the constraints of the film's characters. I painted Ulic as a barbaric Jedi, but the editors thought it would be better to give him a current hairstyle. Although it worked, I prefer the first version because the long hair adds motion and fluidity to the piece."

*(top) The original painting featuring Ulic with long hair.*

*(top and middle left) Pencil drawing showing Ulic and the multi-species group of Jedi. The alternate art as seen on the audiobook package.*

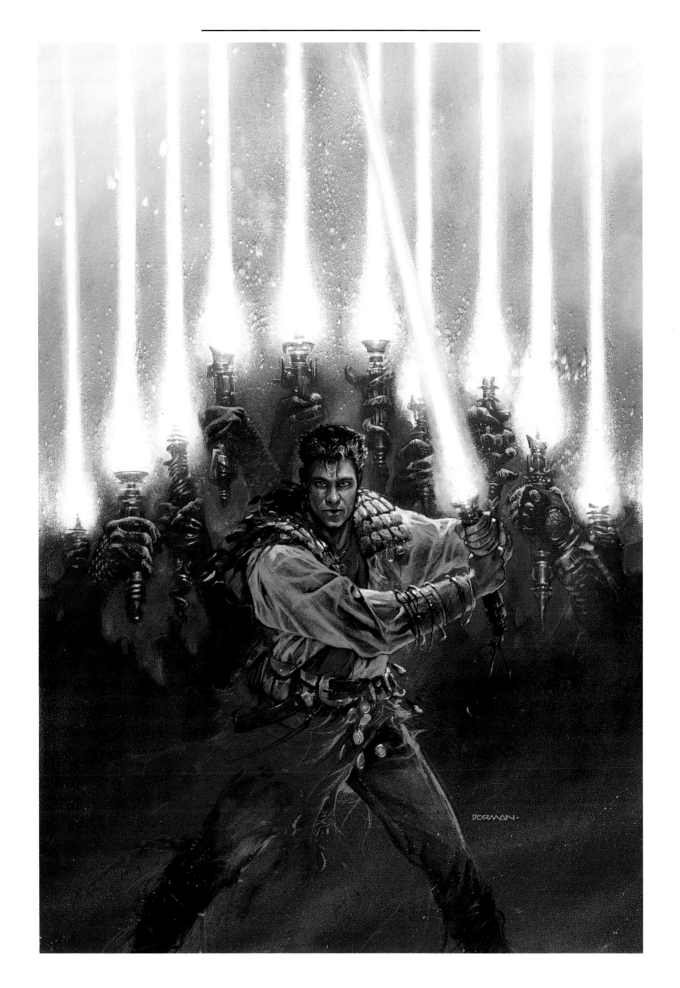

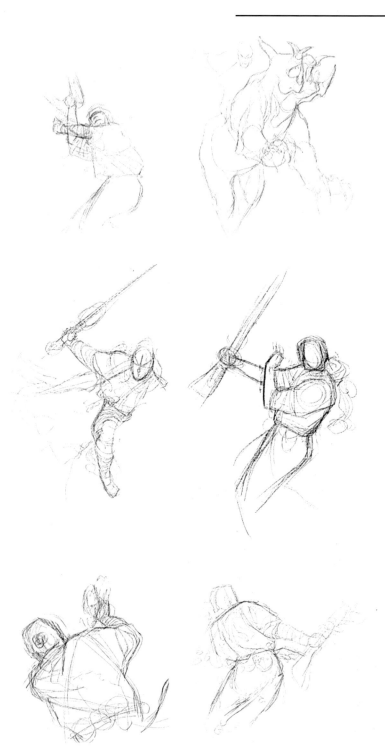

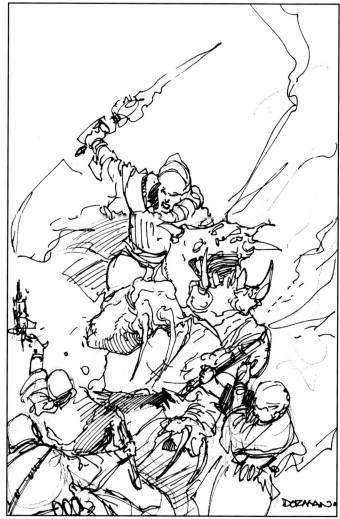

## TALES OF THE JEDI #2

"This painting was my attempt to emulate the illustrations of the great fantasy artist Frank Frazetta. When I read the story, that was the imagery I was struck with and wanted to try. I even altered my color palette to be more in line with Frazetta's work. I'm very happy with the outcome of the piece."

*(above) A compositional rough without the background.*

*(left) A series of figure studies and poses for this piece.*

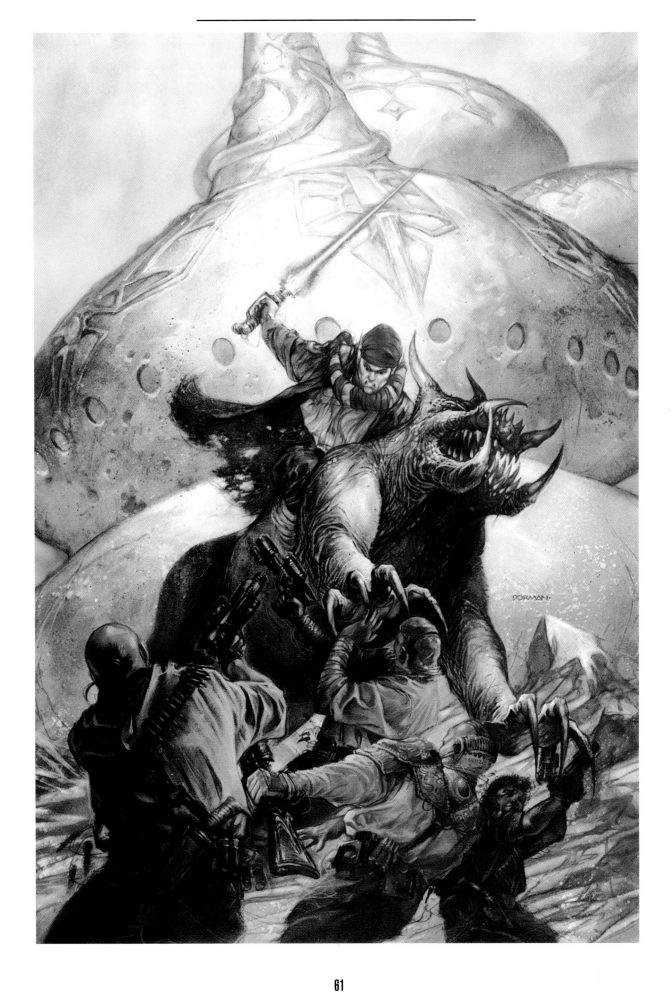

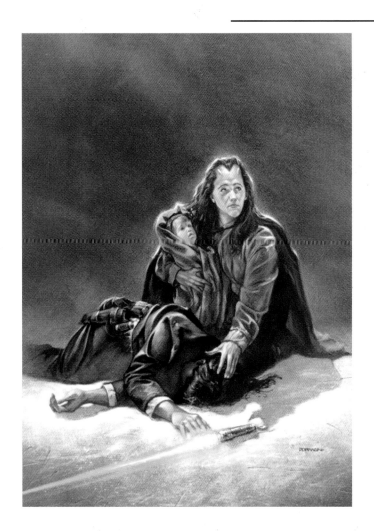

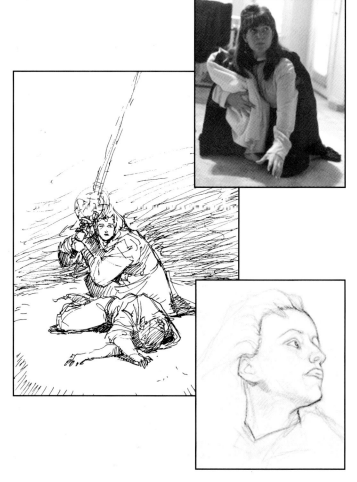

## TALES OF THE JEDI #3

"This story introduced Nomi Sunrider, a farm wife whose husband was a Jedi Knight in training killed at a spaceport. The obvious choice would have been to do an action scene as Nomi avenges her husband's death with the lightsaber, foreshadowing her own journey into Jedi Knighthood. But I chose to do a more introspective piece with Nomi captured in a state of uncertainty. This is an instance where editorial gave into my wishes and let me do it my way. It may not be an action-filled scene, but it works."

*(above left) The original color painting before the head was changed.*

*(above) A layout of the final art along with a photo of Lurene posing as Nomi, and a tight pencil rendering of the head Dave replaced the old one with.*

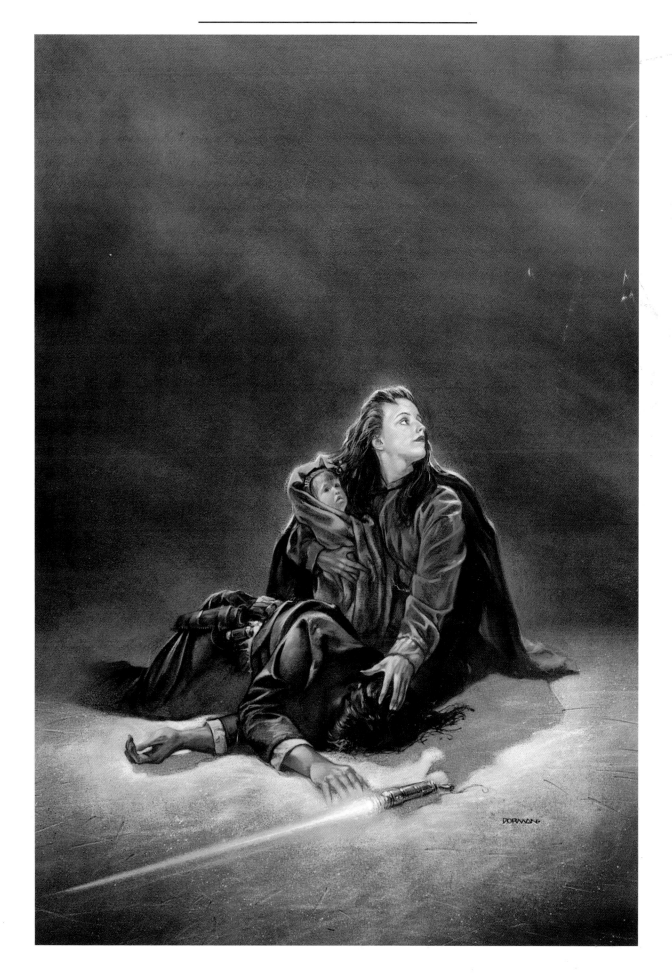

## TALES OF THE JEDI #4

"Perhaps my favorite of this series, I was able to paint a Hutt… not Jabba, but an ancestor, Great Bogga. The original concept was created with a Jedi wielding his lightsaber, but as I read the story, I realized it was a space pirate. I had planned to have a group of the Hutt's henchmen behind him, but when I painted the two main characters, I felt the others would clutter the piece so I left them out."

*(top left to right) A loose "thumbnail" composition piece. A tighter composition. The original concept of a captured Jedi.*

*(above) A detail of the final pencil drawing showing some of the additional characters planned for inclusion.*

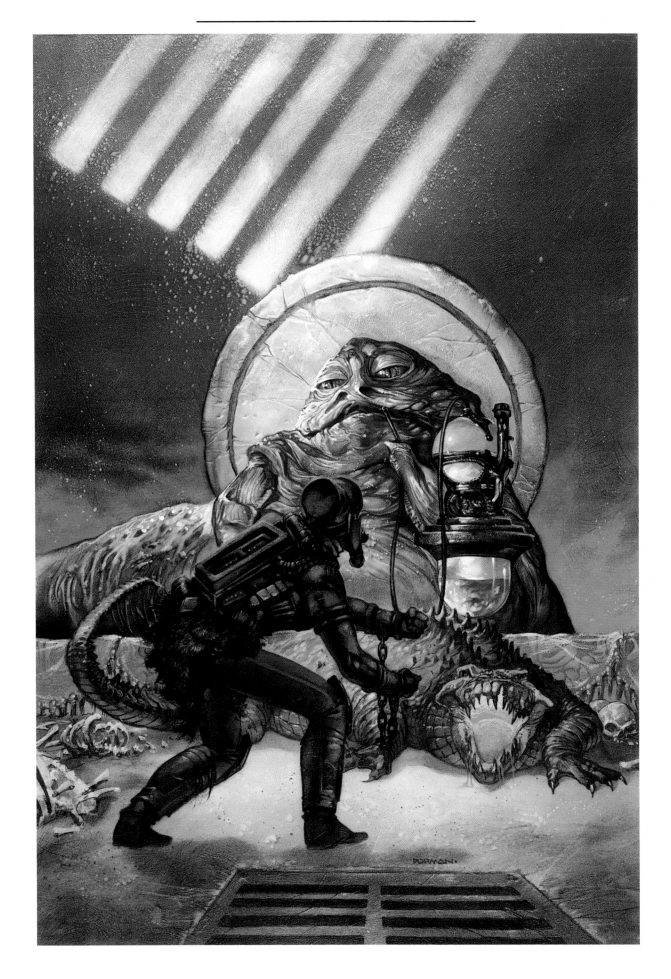

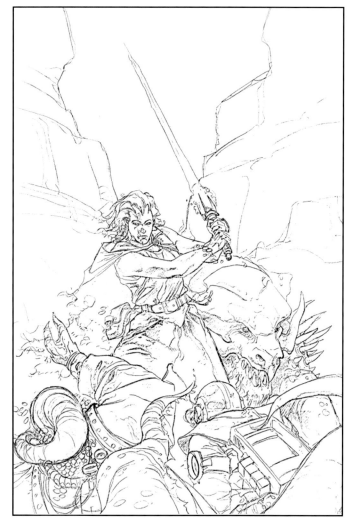

## TALES OF THE JEDI #5

"This was the finale of this series, with Nomi realizing her full Jedi potential, fighting off the pirates. Her Jedi Master, a rhino-like creature, is fighting by her side. Again, I chose to go with the Frazetta colors and drama. I think this is a very nice action piece."

*(upper left) Two rough layouts featuring alternate poses to the final.*

*(above) The tight pencil drawing which the painting was based on.*

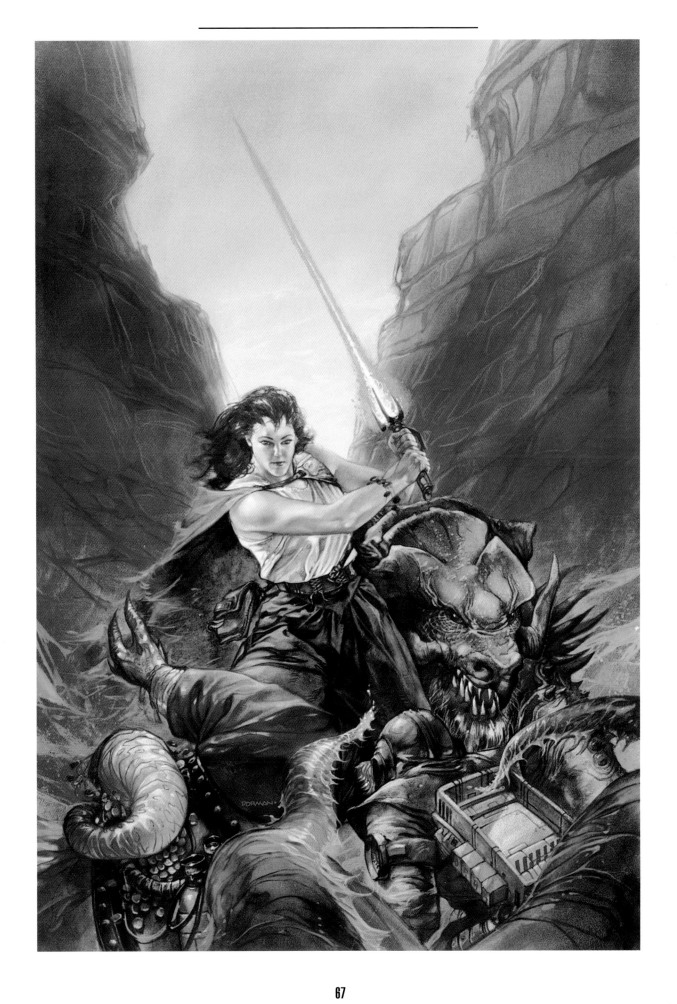

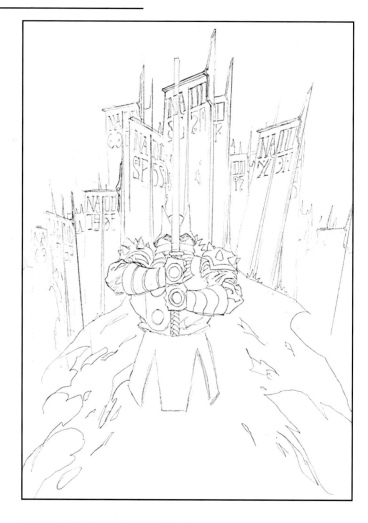

## TOTJ: THE FREEDON NADD UPRISING #1

"This two-issue series actually tied up the loose storylines from the last series. Since it was a two-issue series, I wanted to do two covers with similar complimentary elements while contrasting in character.

*Freedon Nadd* is set on a planet in the clutches of the Dark Lords. This cover showed the Dark Lords as dominant and overbearing, with their standards flying high."

*(above) A pencil drawing for the final art.*

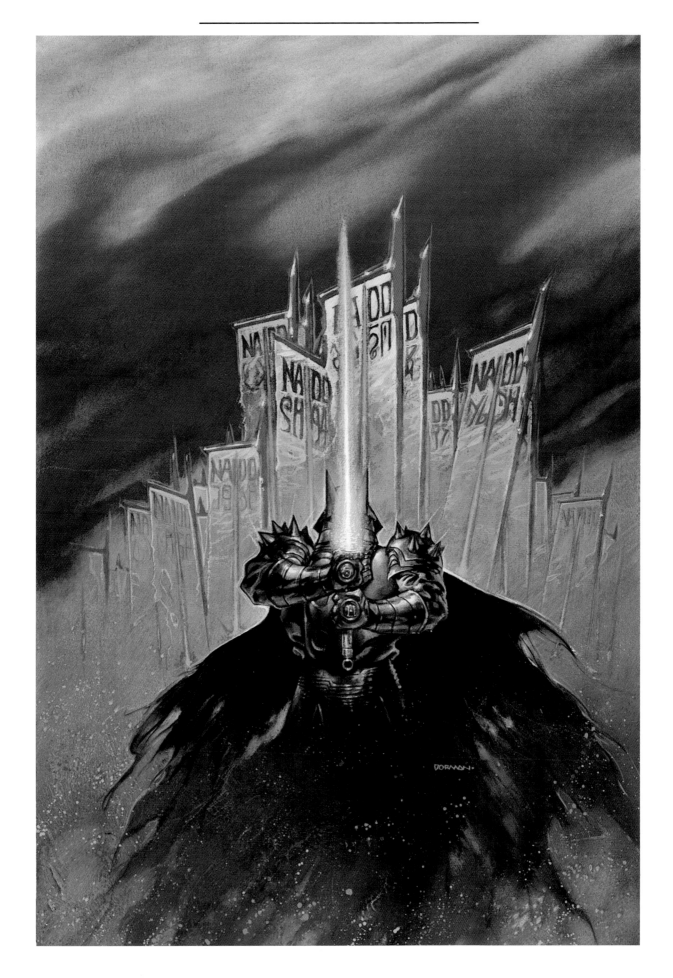

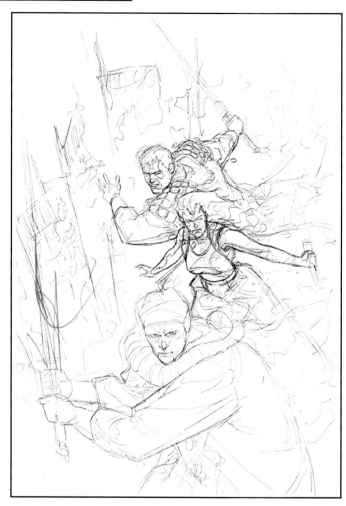

## TOTJ: THE FREEDON NADD UPRISING #2

"In this issue, I show the Jedi, Ulic and Nomi, lead by the Twi'lek, Tott Doneeta, tearing through the Dark Lords' burning standards in what many of my fans say is one of their favorite *Star Wars* pieces."

*(above) A layout for the final art.*

*(above left) Two of the model photos for this painting; Del Stone, Jr. and Lurene Haines. Del modeled for both of the males.*

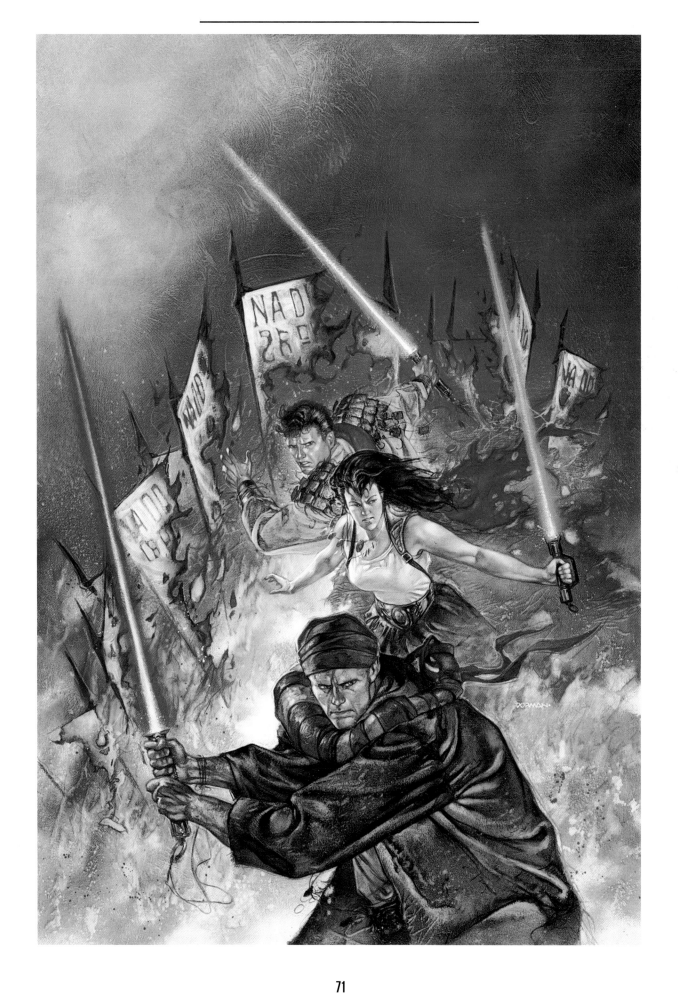

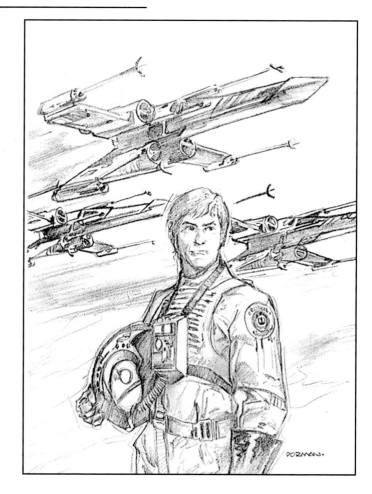

## X-WING: ROGUE SQUADRON #1

"The *X-Wing* series was designed to tie in with a paperback book series that Bantam was producing. The series followed Wedge Antilles, from the *Star Wars* movies, who becomes the Rogue Squadron leader. Dark Horse wanted a likeness of the Wedge character from the movies.

For the first issue of *X-Wing*, we decided to do a recruitment poster-style cover: "The Rebel Alliance Wants You!" I was trying for a WWII look and feel. Now that I see it here without cover copy, it would make a pretty cool poster with that sort of slogan on it."

*(above) A pencil drawing for the final art.*

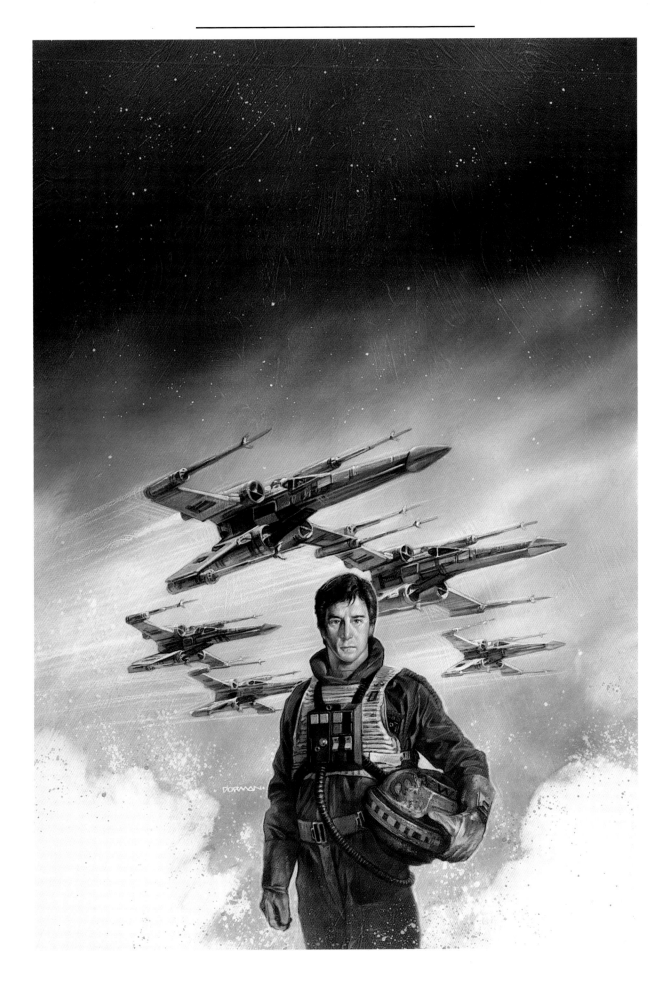

## X-WING: ROGUE SQUADRON #2

"On the second cover, the forced perspective just didn't work for me. I had a problem with it, right from the initial sketch. Of all the covers I did for all the *Star Wars* material, this is the one I'd most like to change if I get the opportunity."

*(above) Two different layouts created for the editors' approval.*

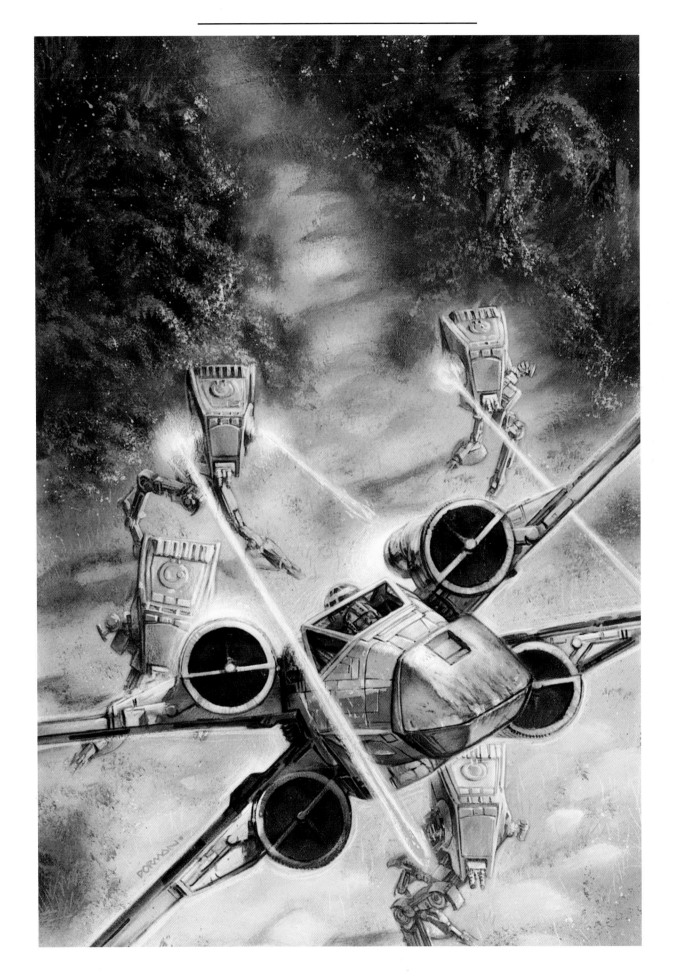

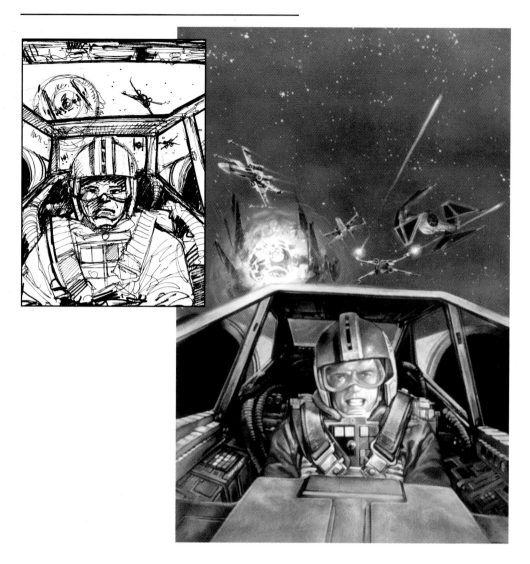

## X-WING: ROGUE SQUADRON #3

"This cover pretty much speaks for itself. It is a shot looking into the cockpit of an X-wing fighter during a battle with some TIE fighters. The original version was done as my reference photos all showed. Basically, there was no reflection on the glass. However, editorial felt the painting made it look like there was no windshield and that the reader would be looking straight at Wedge, so I had to add some reflective lighting."

*(above) The original painted version without window reflections.*

*(above inset) An early rough for the cover showing a straight-forward, if fairly uninteresting, angle.*

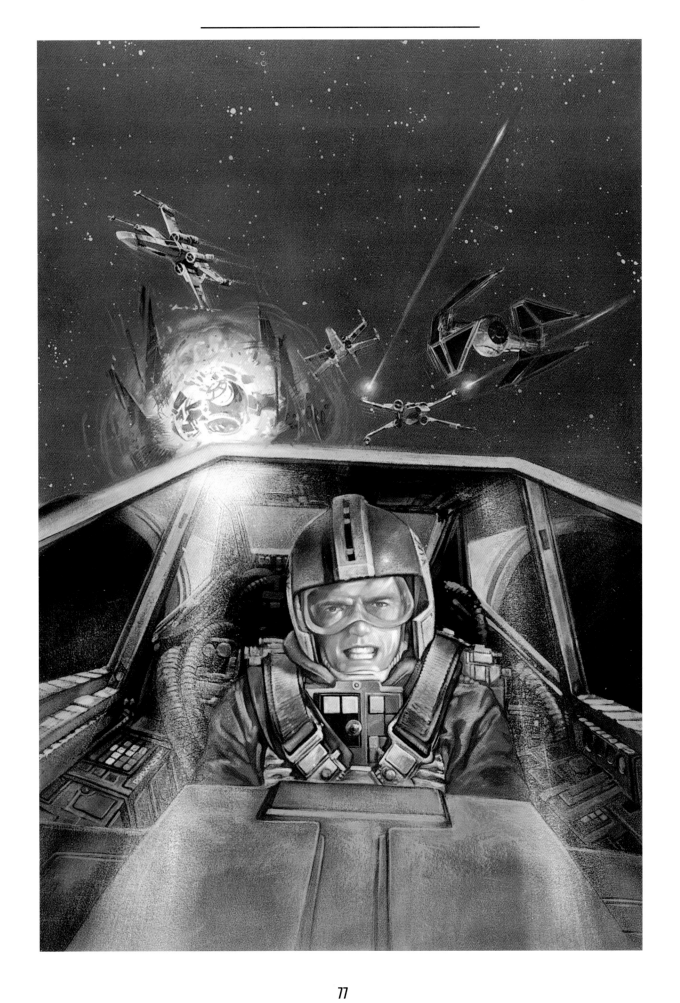

## X-WING: ROGUE SQUADRON #4

"The fourth cover had an interesting complication. Due to a mix-up in the Dark Horse offices, I was sent the wrong reference for the foreground character. The sketch went through all the approval stages—even Lucasfilm—without the mistake being noticed. I did my painting based on that sketch. Lucasfilm then discovered that the foreground character was wearing the wrong costume. In my original painting, the Rebel warrior was wearing his TIE fighter uniform. But the character was supposed to be impersonating an Imperial officer when he gets caught, and needed to be wearing that uniform. I had to decide what to do with the artwork for his transformation. I would have had to either repaint the whole piece, redo the foreground character or paint the figure on a separate board. Because of my painting technique, I chose the third option and the figure was then scanned-in digitally for the final published cover."

*(above left) The printed cover of X-Wing #4 featuring the composite of painting and patch.*

*(below) The patch Dave painted to go over the existing painting.*

# Young Jedi Knights

*In the summer of 1994, Boulevard Books, a division of Berkley Books, offered Dave the challenge of creating covers for their new ongoing series of novels by Jedi Academy author Kevin J. Anderson and his wife, writer Rebecca Moesta. Up to this point, Dave's* Star Wars *work had been exclusively within the comic market. While he had done covers for the Zoot series from Ace/Berkley (a character Dave created), and covers for Bantam's Batman and Aliens paperbacks, this was an excellent opportunity to have his* Star Wars *work seen in the mass market.*

"It was a treat for me when Berkley Books approached me to do the covers for their Young Jedi Knights books, even more so when I learned that Kevin and Rebecca had recommended me.

I love comics. The comics business has been my primary income source for more than ten years, but there's still a sense of excitement when I do covers for the book trade.

Young Jedi Knights took the Jedi history and background, and gave it a "teenage perspective." Leia and Han's children, the twins Jaina and Jacen, along with little Anakin and Chewbacca's nephew, Lowbacca, are the protagonists, being taught the ways of the Jedi Knights by Luke. They go off on adventures of their own in each installment while more Jedi history is explored along the way. While I personally can't relate to these stories, I feel it was a smart move to offer younger readers a sci-fi adventure as an alternative to the Goosebumps and Fear Street books that have become so popular now. One of the models I used, Calvin Engel, the son of cartoonist Jim Engel, is a huge *Star Wars* fan. He took modeling for these covers very seriously. I think he enjoyed knowing that, even though I didn't try for his exact likeness (due to hair color differences, etc.), he was now an active part of the *Star Wars* universe.

These pieces were directed to be montage covers. Working closely with Berkley art director, Judy Murello, as well as Kevin and Rebecca, we decided which characters and arrangements would work best.

The six books represented here are the ones currently in release, but because of the popularity of the series, I am working on more covers. For now, here's a chance to see the art as it has never been published—without the chromium enhancements."

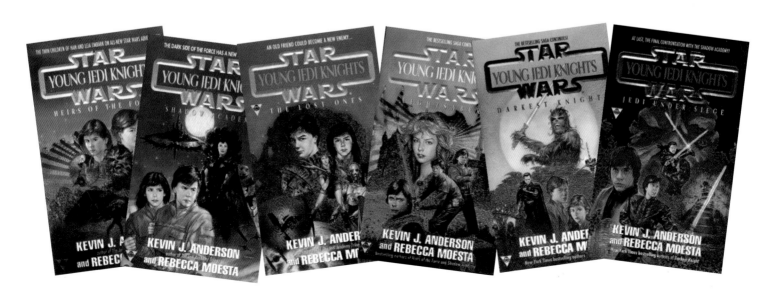

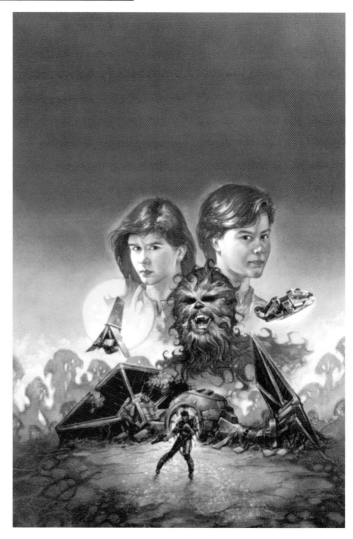

## YJK #1: HEIRS OF THE FORCE

"I thought doing a red-orange background would be a real grabber on the stands. Above the treeline, and around the characters, is an even gradation to the top. When I turned in the painting, I found out they were doing the chromium foil. As a result, I was asked to add a sort of "border" to the artwork to act as a trap for the foil. So I repainted the background to have a celestial edge."

*(above far left) A rough of the Young Jedi's skyhopper, the same ship seen in the first movies as a model Luke is playing with. (above left) The original rough done in a hotel room shortly after learning he had been given the project. (middle left) A rough figure pose of the wounded TIE fighter pilot and a photo of the model for Jaina, Kristin Marshall.*

*(above) The original painting for the cover with plain background and some minor differences in the faces and hair, most noticeable on the Jaina character.*

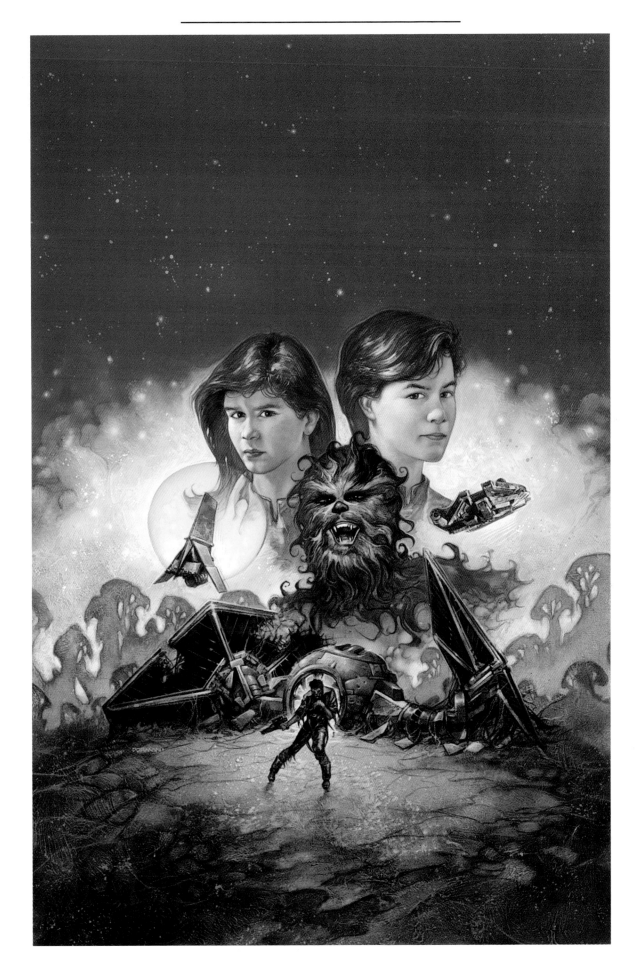

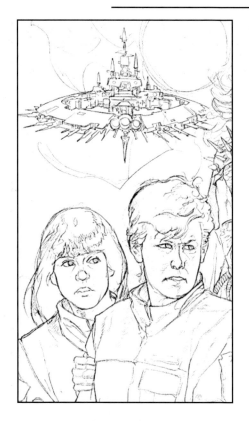

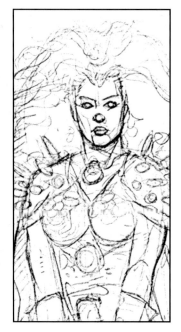

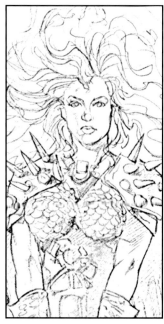

## YJK #2: SHADOW ACADEMY

"This gave me the chance to paint the overlord of the Dark Academy. It was a good opportunity for me to design some elaborate costuming and to paint a pretty girl… pretty, but nasty!"

*(top left) A detail from the tight pencil drawing of Jacen and Jaina. Suspended behind them is the Shadow Academy, a typically imposing Imperial-looking structure.*

*(left) Calvin Engel, the model for Jacen.*

*(above) The loose and tight pencil versions of the beautiful but evil Head Mistress of the Dark Academy.*

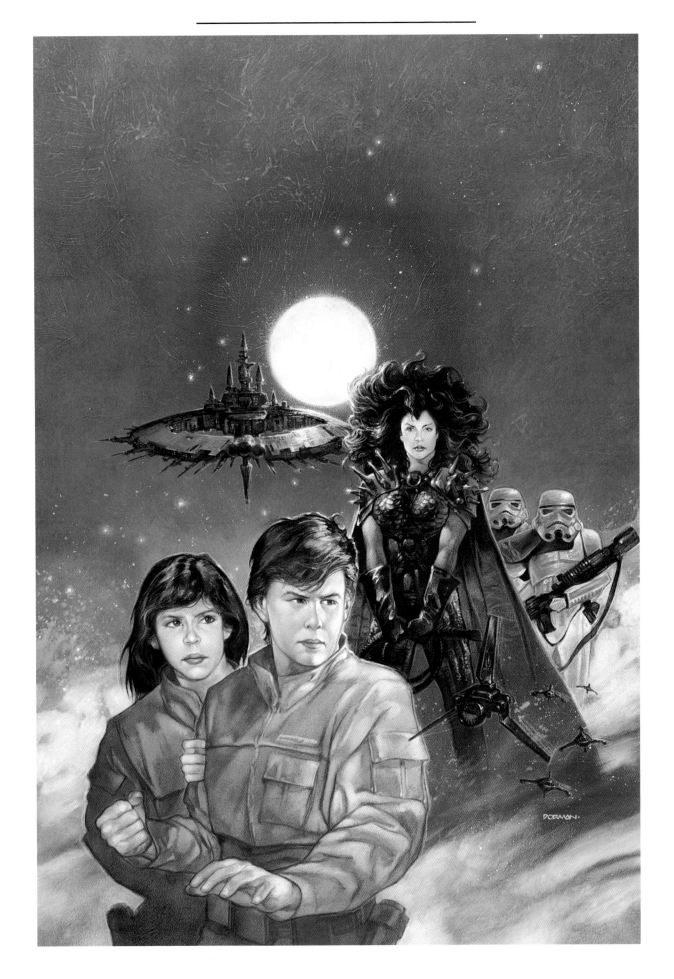

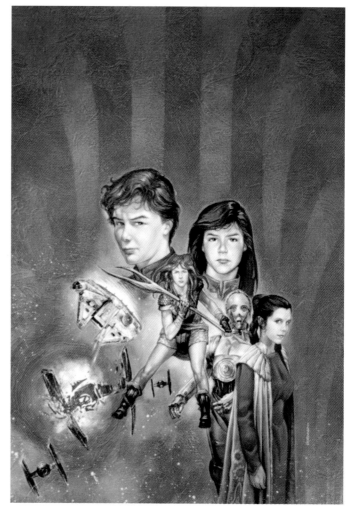

## YJK #3: THE LOST ONES

"This painting posed a bit of a problem because I had a hard time figuring out what to do with the background. I was told by the art director that the original painting's background looked too much like a circus tent. I was merely trying to provide a graphic element that suggested movement. Looking at it now, I don't know what I was thinking, but when I changed it, everybody was happy. The revised version worked much better and also made for a better border for the foil."

*(top left) Two preliminary roughs.*

*(above) The original painting, featuring the "circus-tent" background.*

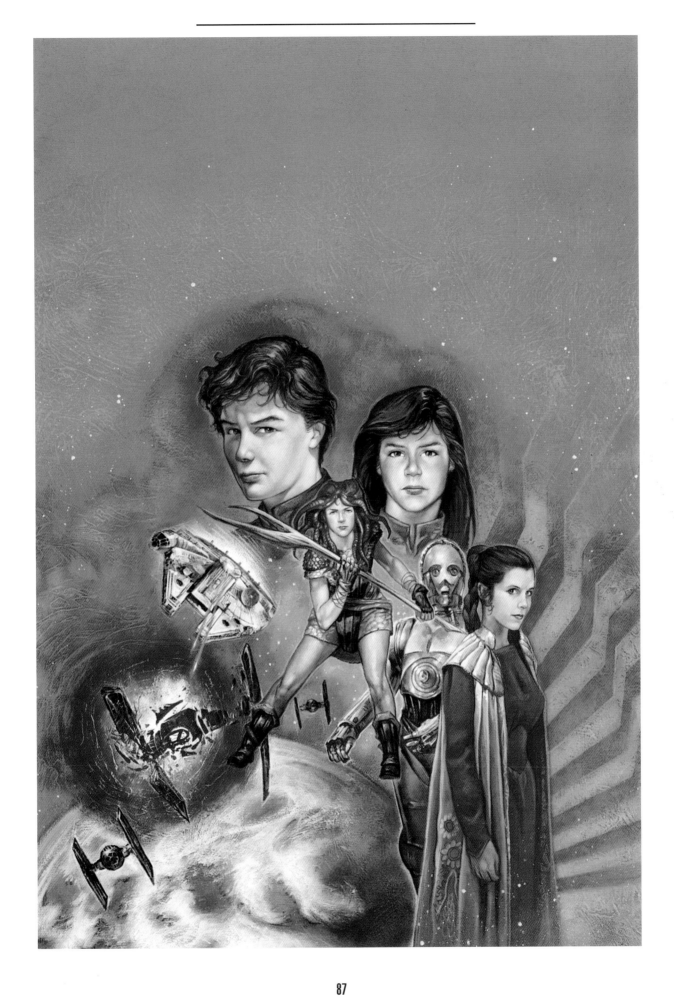

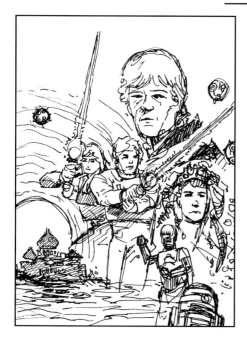 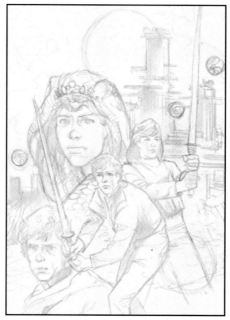 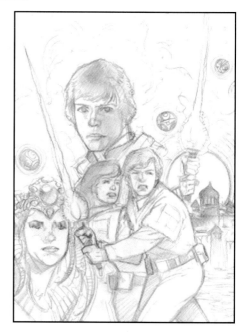

## YJK #4: LIGHTSABERS

"This cover featured Tenel Ka, the red-haired girl who I think turned out very pretty. Actually, I think the red color scheme worked well overall in this painting.

One change I had to make was in the lower right-hand corner of the book. I had painted in some Star Destroyers but afterward I learned there weren't any in the story. I substituted the Shadow Academy for the Star Destroyers in the final version."

*(top row) Three different presentations of what would become the final cover. Because of the complex elements, it was necessary for Dave to create tight pencil versions of more than one design.*

*(left) Calvin Engel, the model for Jacen, and Kristin Marshall, the model for Jaina.*

*(below) A detail from the original painting showing some of the Imperial ships not seen on the final book cover.*

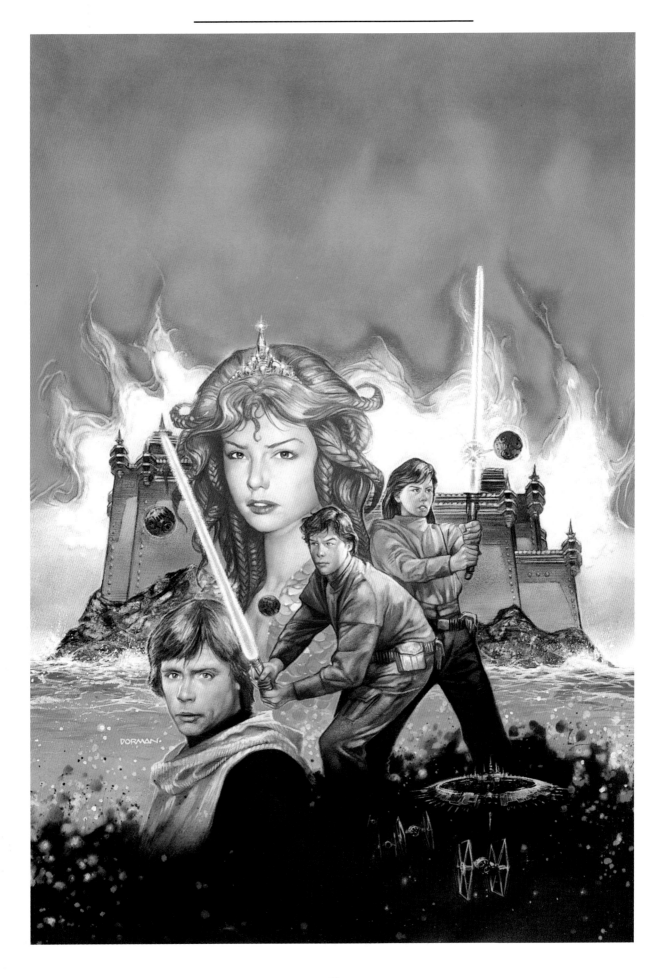

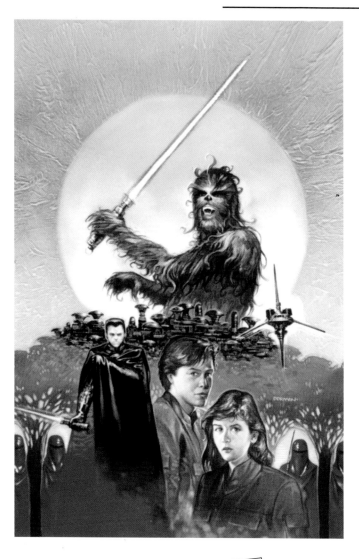

## YJK #5: DARKEST KNIGHT

"This story concentrated on Lowbacca, so he became the major element in the painting, contrasting, as I've done in each of the books, with a strong color tone that was different from the previous cover. I went with a bright yellow sun behind Lowbacca, complementing it with the green of the tree-top city, and contrasting that with the strong red of the Imperial Guard, placed in the picture to represent the dark element that exists in the *Star Wars* universe all the time.

However, there were some changes to this piece. The character of Zekk, I was told, looked a bit too much like a vampire, so I had to change his costume. And the tree-top city in my painting was not quite what Lucasfilm wanted and I had no reference for it anyway, so it was decided that I should take it out and just leave an umbrella of trees."

*(top left) The original painting showing the tree-top city which was later deleted.*

*(above) The tight pencil drawing showing the vampire-like dark pupil, Zekk.*

*(left) Kevin J. Anderson's storyline complete with Dave's character thumbnails.*

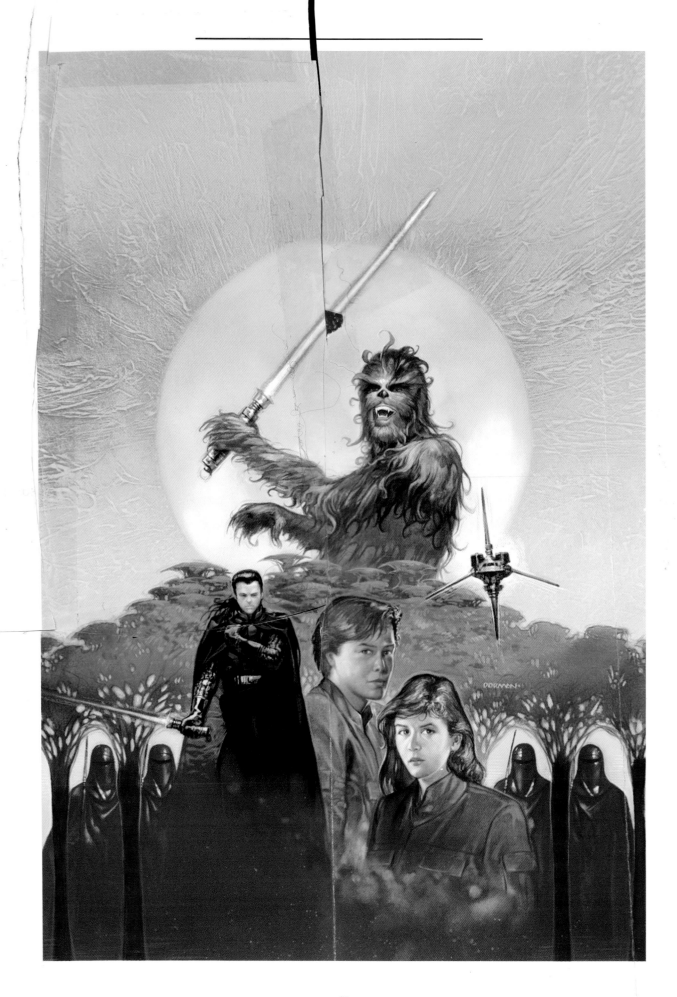

## YJK #6: JEDI UNDER SIEGE

"This was the final book of the initial
six-book series. I tried to add some action with
the characters and the lightsaber fight. I think the
Emperor's strong presence makes this a very
powerful cover"

*(above) The rough for the cover. There are no significant
differences between it and the final painting.*

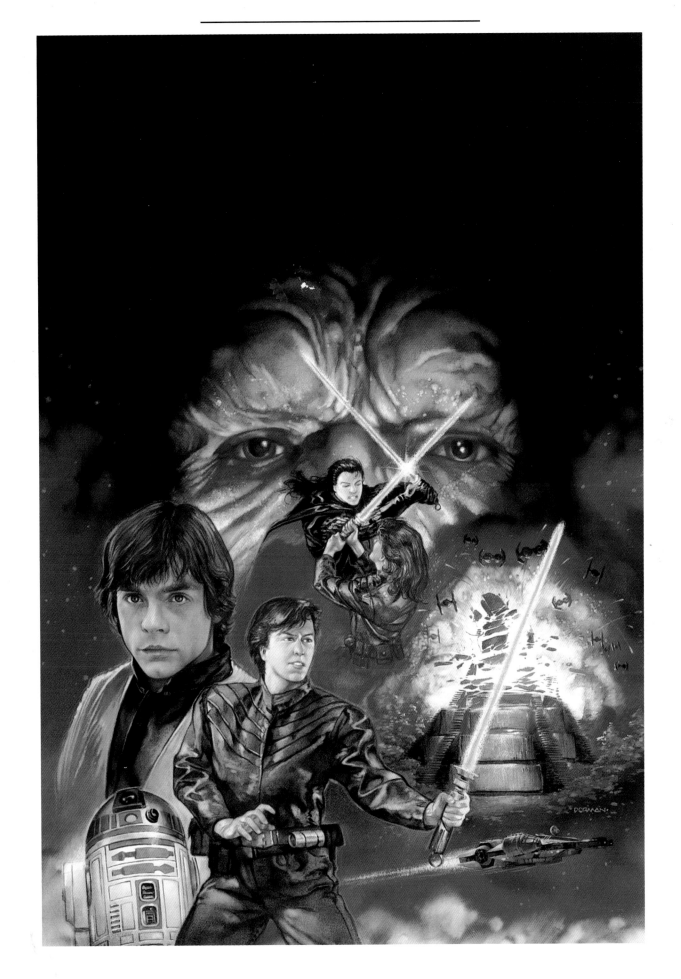

# Rolling Thunder & Beyond

*Since the first cover of* Dark Empire *was released, the number of spin-off products has been steadily increasing. It is not uncommon for a piece of art to be used over and over again. But with Lucasfilm's high standards for quality, this rarely happens. Instead, and especially with Dave, more licensees contacted him for* Star Wars *work outside of comics. Needless to say, this book does not mark the end of Dave's association with* Star Wars. *Far from it. There are currently projects on his drawing board ranging from model kit packaging to paperbacks to premiums.*

"Because of my relationship with Lucasfilm, I have been able to go beyond the limits of most illustrators. My company, Rolling Thunder Graphics, currently has the license to produce limited edition art prints of my *Star Wars* paintings. These have been so popular with fans that almost every edition we've produced has sold out.

I have done some pretty interesting projects for other companies as well. And with the steadily increasing popularity of the *Star Wars* universe, I hope to be involved in many more products in the next few years.

The following pages showcase miscellaneous projects I have been involved with."

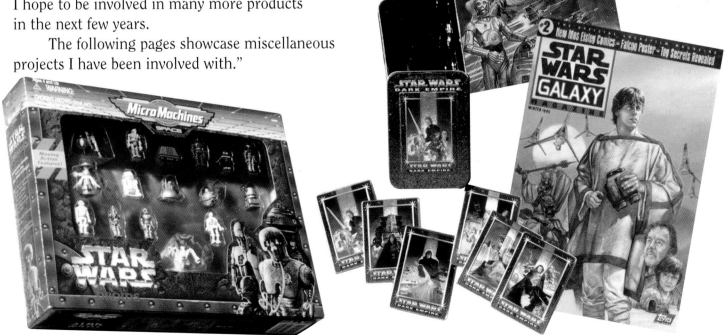

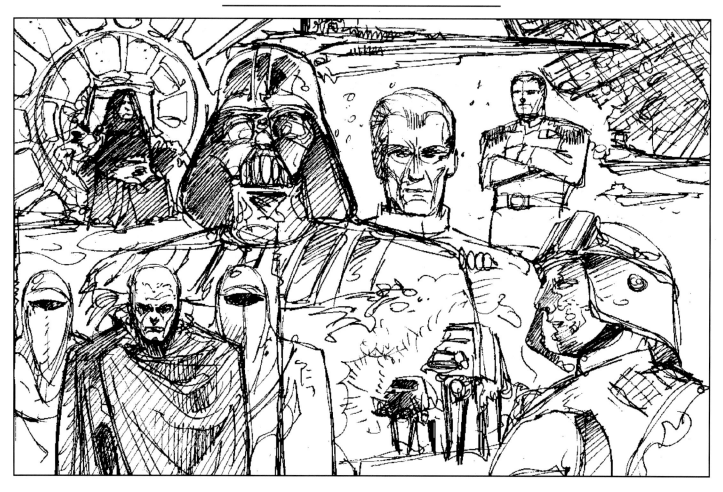

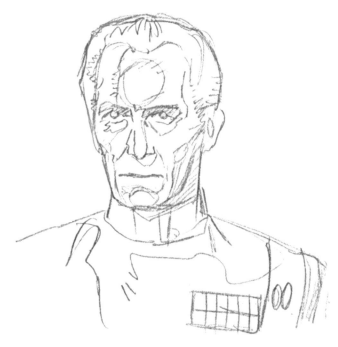

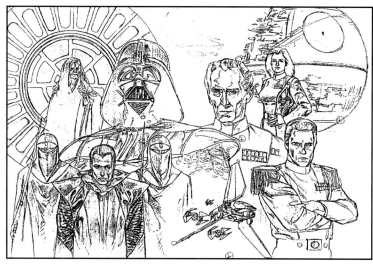

(top) The original layout done for approval featuring General Veers.
(lower right) Some different elements were changed for
the final version.

(above) A layout of the final painting featuring a more prominently
placed Grand Admiral Thrawn and the addition of Admiral Daala.

(left) A loose drawing of Peter Cushing as Grand Moff Tarkin.

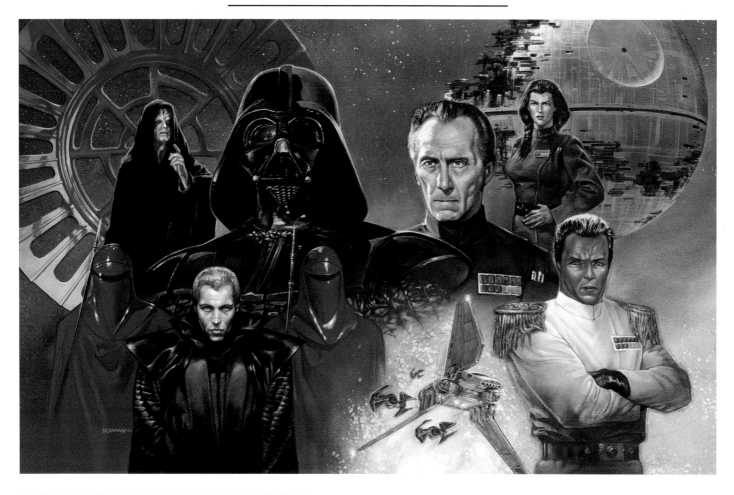

## THE MAGISTRATES OF THE EMPIRE

"This was an assignment for *Star Wars Insider* magazine. They commissioned me to create a piece showing a number of the bad guys in a montage situation. Here, I utilized both characters introduced in the films as well as new characters introduced in the books, like Grand Admiral Thrawn and Admiral Daala. This also gave me an opportunity to do Grand Moff Tarkin. Peter Cushing was always one of my favorite actors in Hammer films. It was a great thrill for me to see him in *Star Wars* when it was released. I had always wanted to paint him in a scene but until this piece, the opportunity never arose.

I had originally wanted General Veers, who was the walker commander in the second and third films, as the element in the bottom right of the image. This was changed to Grand Admiral Thrawn.

This is one of my personal favorites of the *Star Wars* pieces I've worked on."

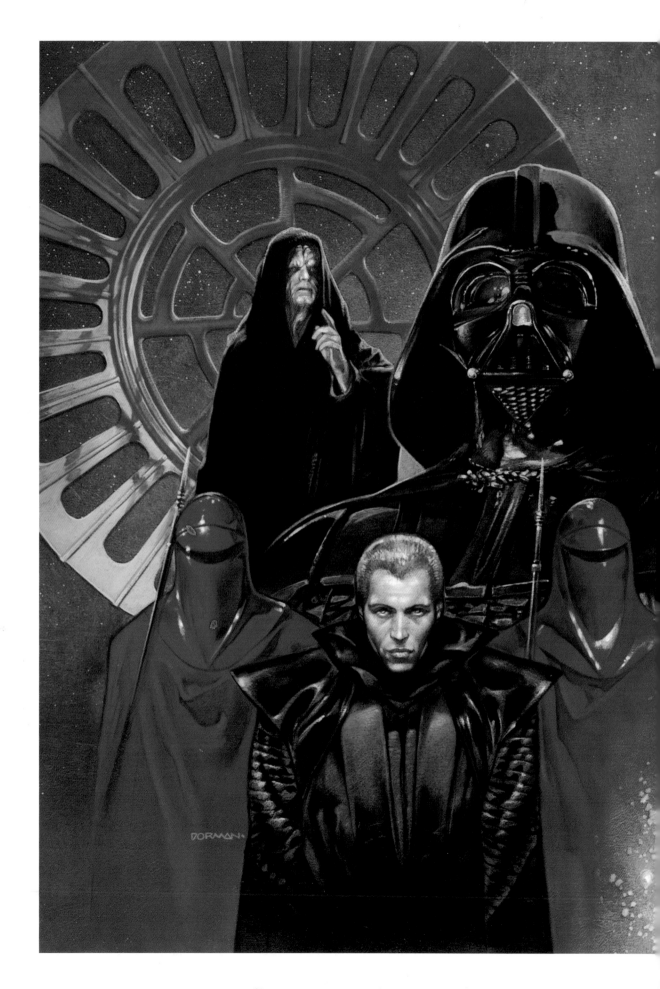

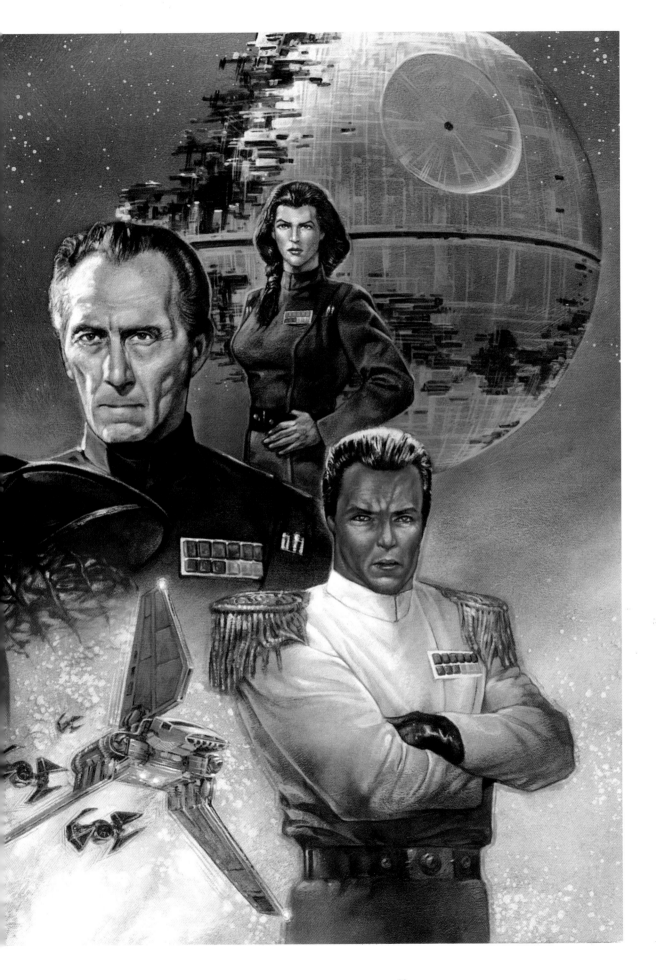

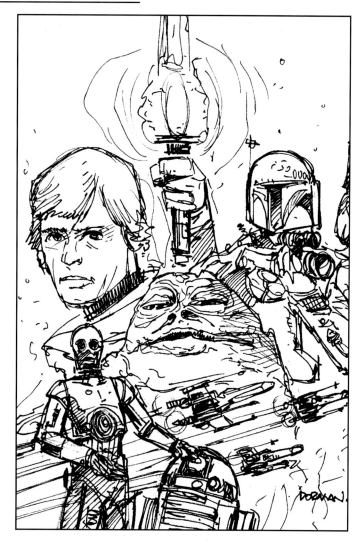

## STAR WARS MONTAGE

"The cover to *Hero Illustrated* was originally done as an overview of what Dark Horse Comics was doing at the time. I took an element from each of the current books and put it into the image to create a montage. There is Luke from *Dark Empire II*, Jabba the Hutt from his mini-series, an X-wing flight symbolizing the *Rogue Squadron* series and Boba Fett from his (at that point forthcoming) mini-series. The lightsaber was added to symbolize the growing power of the Force and the triumph of the Jedi over the dark side."

*(above) A layout of the final painting.*

*(left) A detailed pencil rough of a hand holding the lightsaber.*

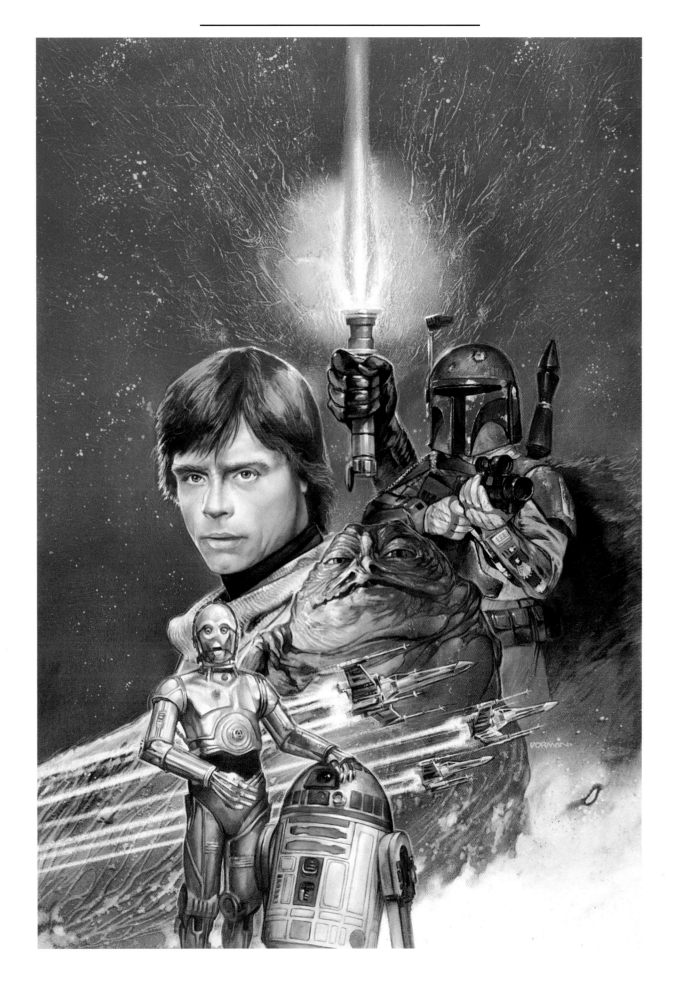

(top right) An early rough of the "Droids" painting featuring an alternate background.

(top left) The Topps trading card featuring the art plus typography.

(above) The art as it appeared on a Star Wars Galaxy milkcap.

## DROIDS ONLY

"This card was my first piece for Topps. I did it immediately following my covers on *Dark Empire*. It was a chance for me to move away from the characters from the comic series yet still do personalities. I had wanted to do Grand Moff Tarkin for the card, but Scott Hampton beat me to it. So I chose to do a group of droids. The "Droids Only" sign was a joke based on a scene from the trailer for *The Empire Strikes Back* where C-3PO is shown tearing a sign off a door that reads "No Droids Allowed." The scene didn't appear in the film, but was mentioned in the novelization.

This painting was originally done as a trading card painting roughly the same size as shown at right. It has since been used as a milkcap, and on the packaging for the Micro Machines Droids set."

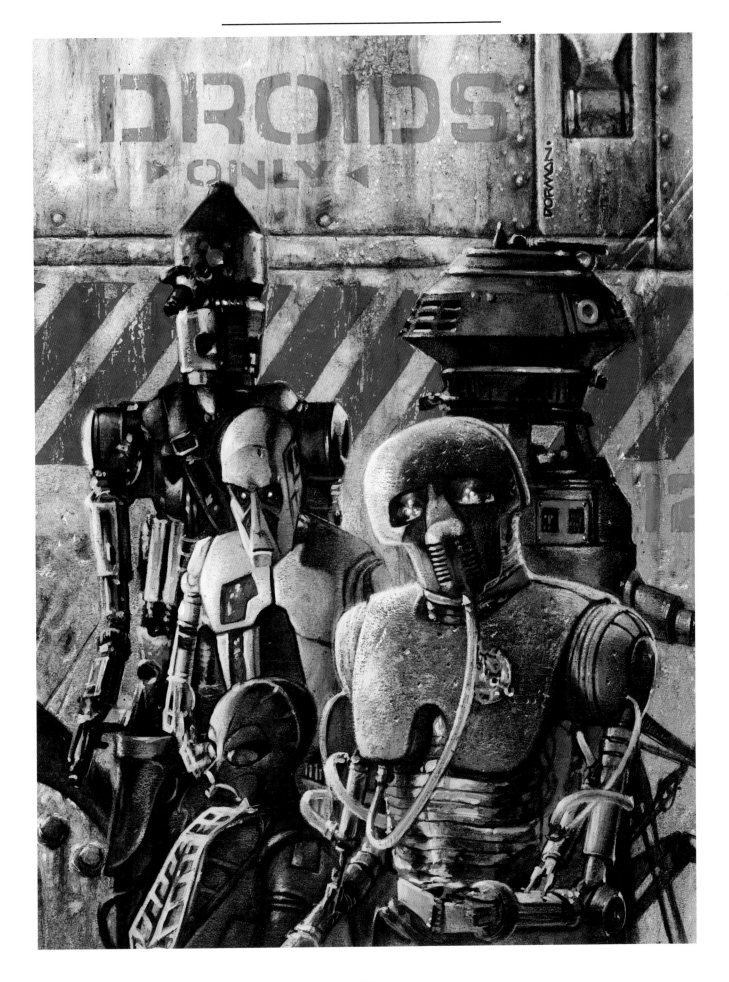

## YOUNG LUKE ON TATOOINE

"Luke on Tatooine was commissioned by *Star Wars Galaxy* magazine as the cover for their second issue, which also included an interview with me. For the cover, the editors wanted to avoid any connection to the *Dark Empire* series. One of the articles in that issue was on the beginning of the NPR radio adaptation of *A New Hope*. This gave me the inspiration to paint Luke on the farm; still innocent, still a dreamer. I liked this piece quite a bit. But for some reason, when it was printed in the magazine, the scan was distorted, so all of the figures were taller and thinner, distorting the features somewhat."

*(Top and left) Three layouts of varying detail all showing the same theme with different poses.*

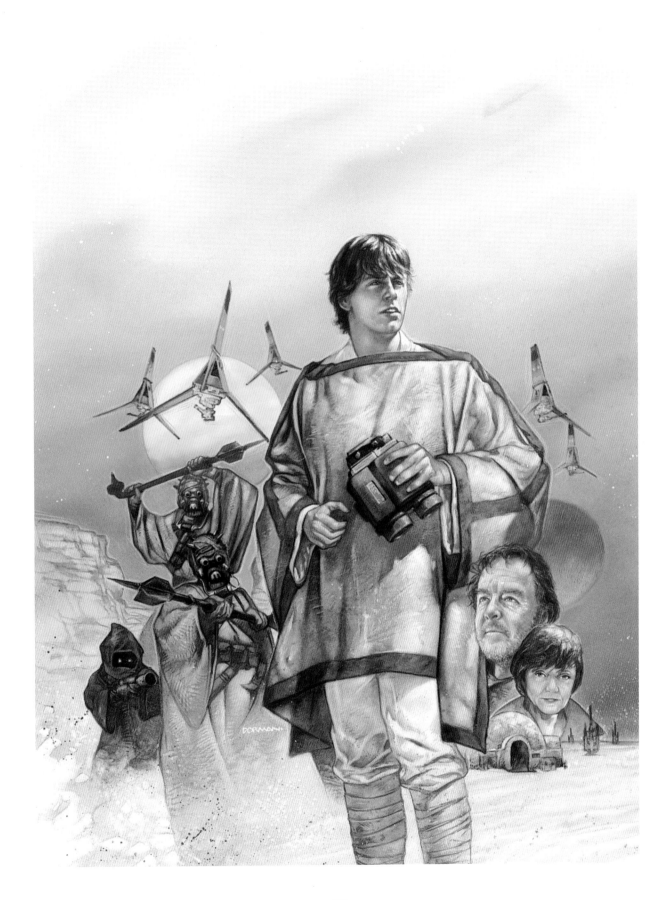

## LUKE ON HOTH

"This was a painting I thought worked well for me. I had been doing so many "dark Luke" pieces and so many "Luke as a warrior" pieces, I wanted to open him up a bit and give him a lighter look. I did him in Hoth gear, eliminating the dark mood. This is the "good-guy Luke."

*The Empire Strikes Back* made a big impression on me, expanding on the first film as it did with new environments. When I finished the piece, I realized that, like the cover to *X-Wing* #1, this could almost be a recruitment poster for the Jedi Knights."

*(above) A tight pencil layout for the final painting.*

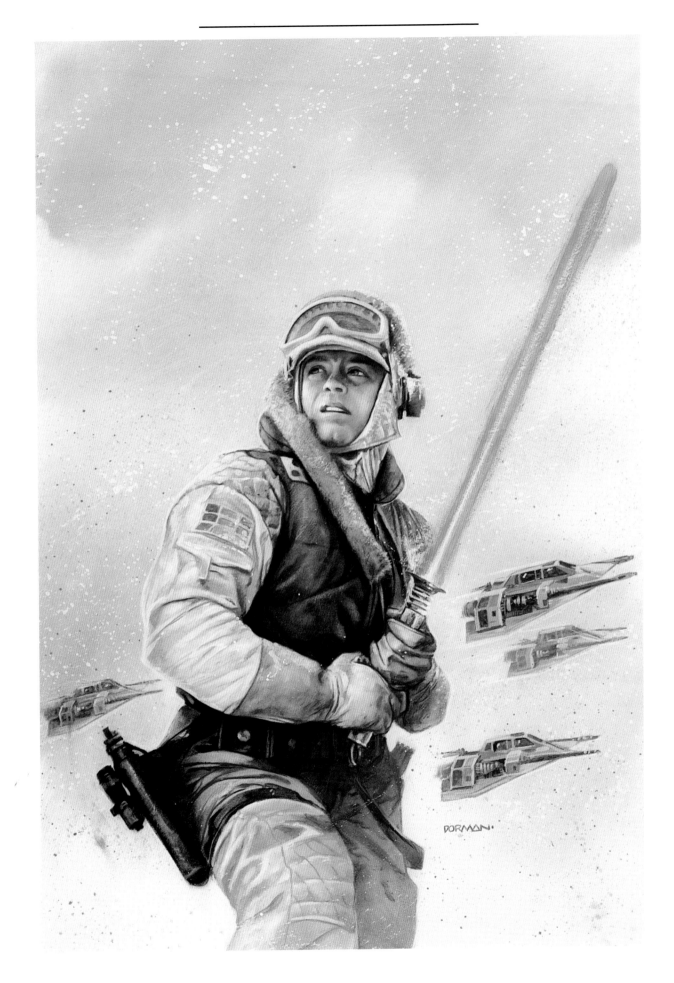

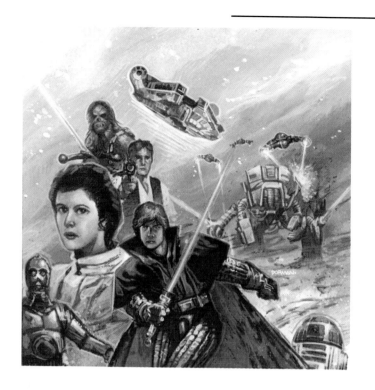

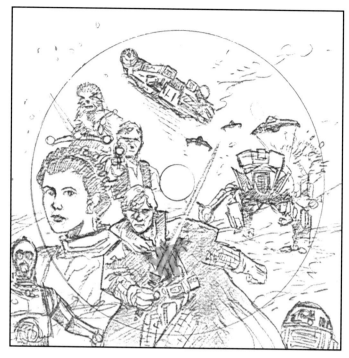

## DARK EMPIRE: THE GOOD GUYS

"At the ABA Convention in Chicago in 1995, I met with Time-Warner about creating the packaging for their first books-on-CD product, which was a dramatic interpretation of the *Dark Empire, Dark Empire II* and *Empire's End* comics.

Over several weeks, the project evolved from creating package design to art on the disk. They wanted one piece to represent each series, but had a budget for only two paintings, so we agreed one piece would be for the good guys and the other for the bad guys."

*(above left) A color comp done in an afternoon for use in a bookseller's catalog. The piece was made into a color copy, cut out and mounted on a CD. It held up well when pictured small.*

*(above) A tight pencil layout for the final painting.*

*(right) The front of the actual product package with a die-cut window showing the artwork on the disk.*

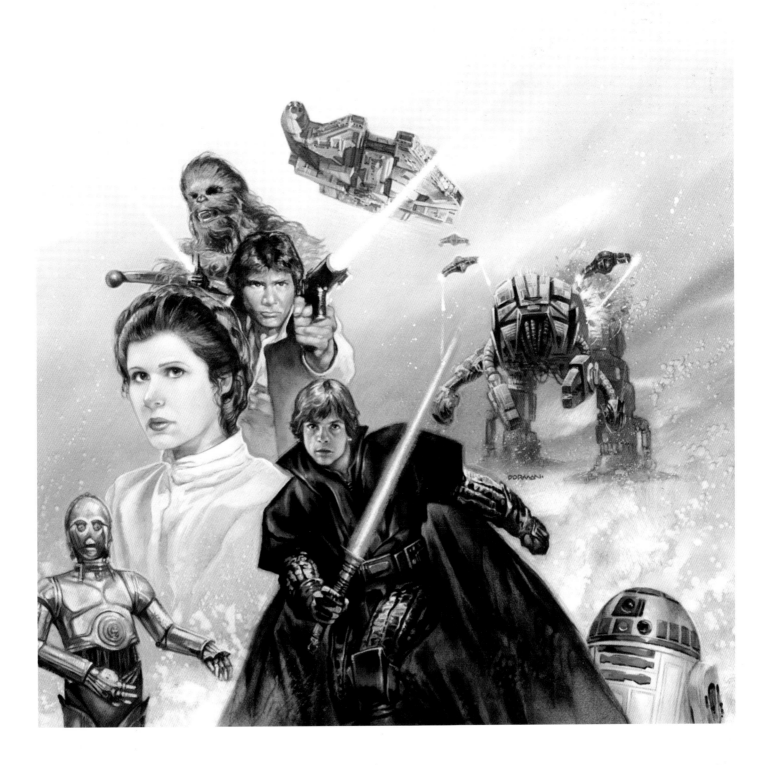

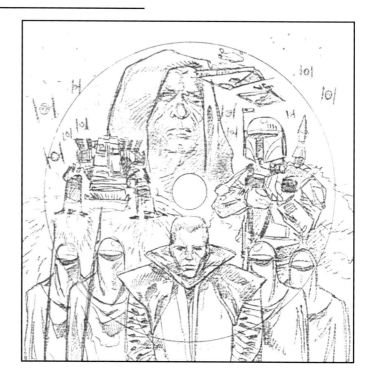

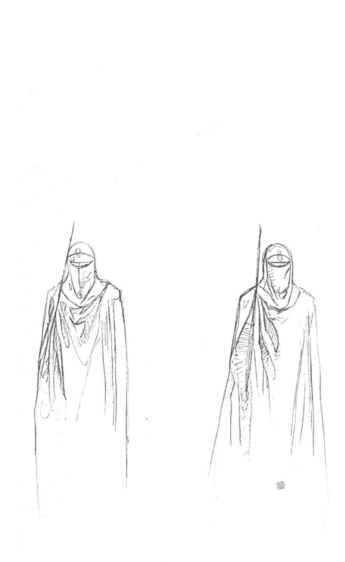

## DARK EMPIRE: THE BAD GUYS

"This is the companion piece to the painting on page 109. Notice the full image area compared to the CD cropping which, until now, was the only image available."

*(above) A tight pencil layout for the final painting.*

*(left) Roughs of the Imperial Guards used on the disk. These same guards have been used as an element on the cover painting for Young Jedi Knights and* Empire's End.

*(below) The back of the actual product package with a die-cut window showing the artwork on the disk.*

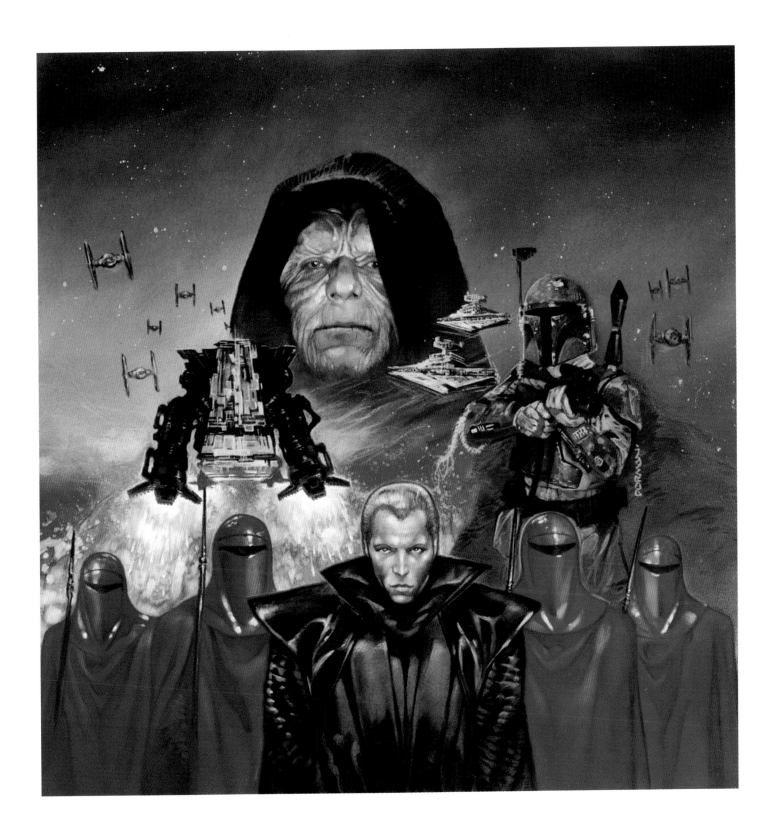

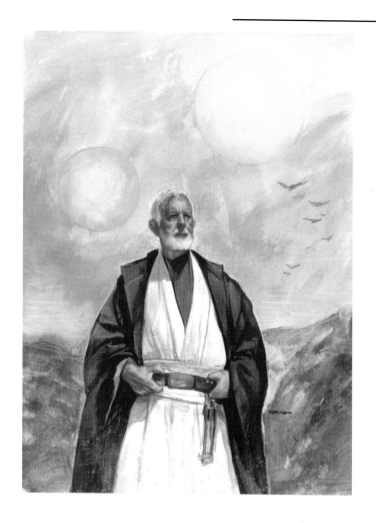

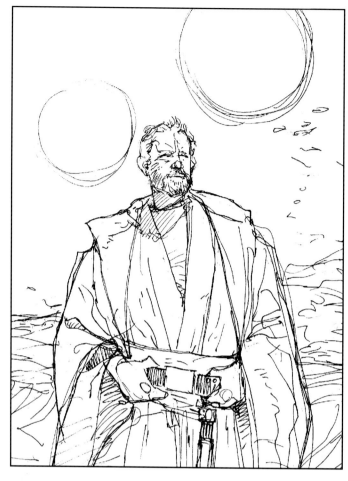

## OBI-WAN KENOBI

"This is a piece I've wanted to do for a very long time. Since I publish prints of my *Star Wars* work, I decided to commission myself on this one. This is introspective Ben Kenobi, before he comes out of retirement and back to assist in the effort of the Rebellion.

I think this painting is very regal in both pose and composition. The two suns behind him also add to the balance of the piece. I love this painting and it's among my favorites in this book."

*(above left) A color rough done as a sales tool in marketing the print.*

*(above) A tight pen rough for approval purposes.*

*(left) A figure study.*

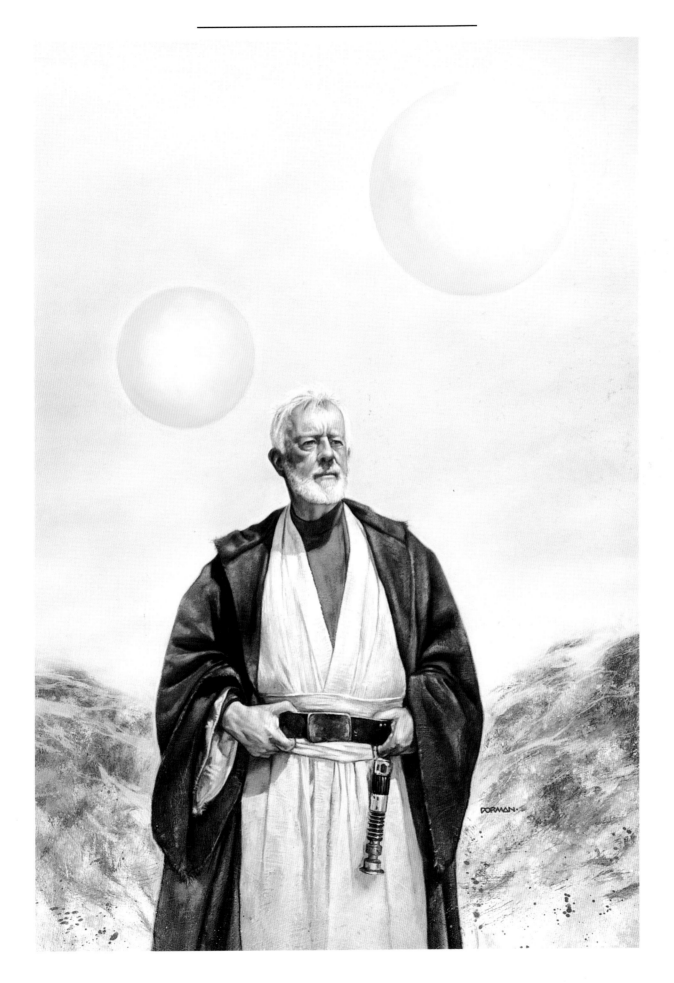

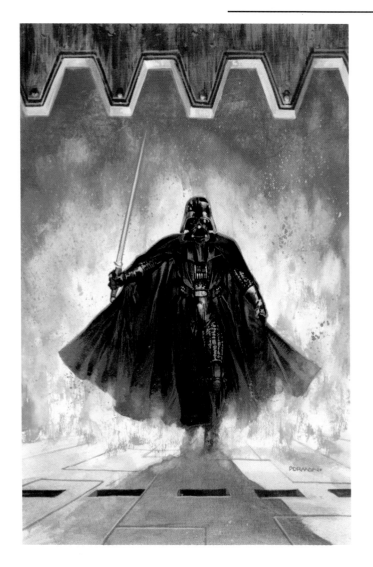

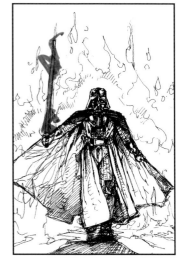

## DARTH VADER

"I did Darth Vader as the second in the portrait print series as an extreme contrast to the Obi-Wan Kenobi print. I show Darth walking through the fire; a symbol of evil coming at you out of flames. My original concept merely had him coming at you with his lightsaber poised, but the flames within the large mechanical door proved to be a very powerful image. It gives the impression that he is coming through a series of sharp teeth."

*(above left) A color rough done as a sales tool in marketing the print.*

*(above) Progressive rough layouts.*

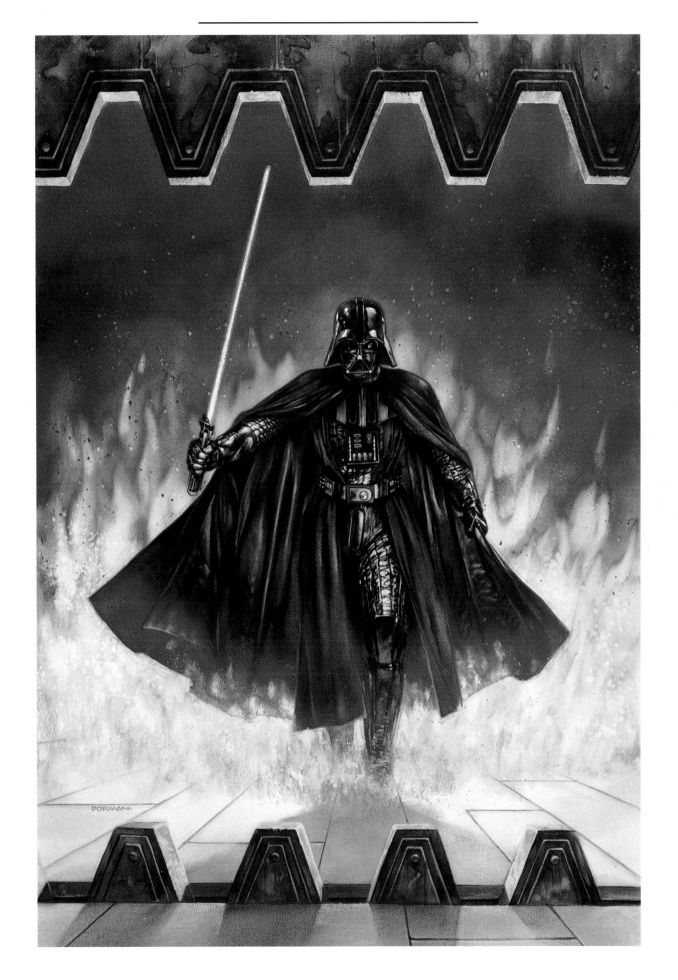

## HEROES OF THE ALLIANCE

"This piece was done as a special premium print offered only in a coupon book packaged with the most recently released boxed set of the *Star Wars Trilogy* from Fox Video.

Here I took my initial piece from the very first *Dark Empire* comic which featured a movie poster-like interpretation of the main characters. I added some elements and changed other elements to better tie the piece to the film: mainly, the Vader helmet in the upper starfield. I also changed Leia's face to be prettier, like she was in the films, and changed the color scheme to reflect the foreboding nature of Vader and a very swashbuckling Luke.

This piece turned out well and was a great complement to the original painting done several years earlier."

*(above) A tight pencil drawing done for approval purposes.*

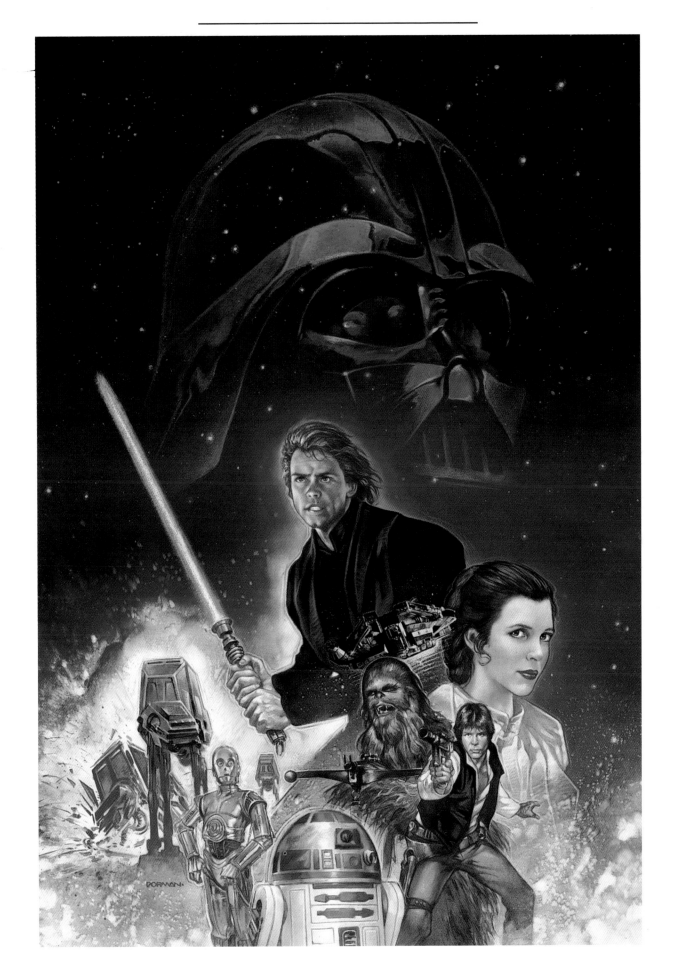

# Technique

(above) Dave Dorman at work in his home studio.

Dave Dorman has carved a prominent place for himself in the field of fantasy art with his richly textured, dynamic paintings. His enthusiastic fan base should be no surprise when you consider the amazing work this talented artist produces, and, in particular, the way he realizes imaginary characters and events.

However, there is an enigma surrounding Dave's technique. Many artists and fans are convinced Dave's renderings are accomplished in acrylics. But most express doubt and surprise when they learn he works almost exclusively in oils. But this self-taught artist has developed a painting technique that beautifully complements his vivid imagination and detailed pencil renderings. Now, for those of you who have wondered how he did it, his techniques are presented here, step-by-step.

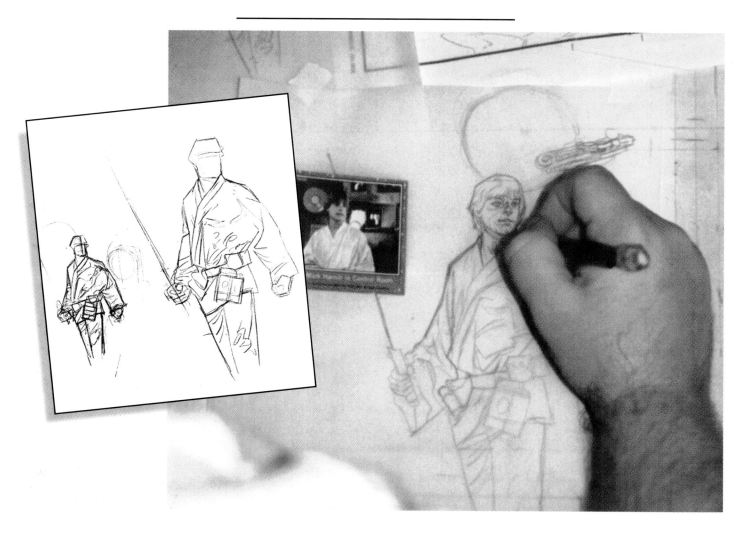

1) Once a sketch has been approved, Dave gathers his photographic reference. For paintings featuring original characters, Dave has a model pose for photos. Yet, for many of his *Star Wars* pieces, he must work from movie and promotional stills to ensure exact likenesses of established characters. The photos are only for lighting, position, clothing folds and likenesses. With the aid of these stills, Dave can then transform his rough sketches into a tighter drawing. Above, he has found photographs from magazine covers, trading cards and movie stills in an effort to achieve the likenesses of Luke, Obi-Wan and Darth Vader. Using these photos, he begins to create a tighter sketch on tracing vellum.

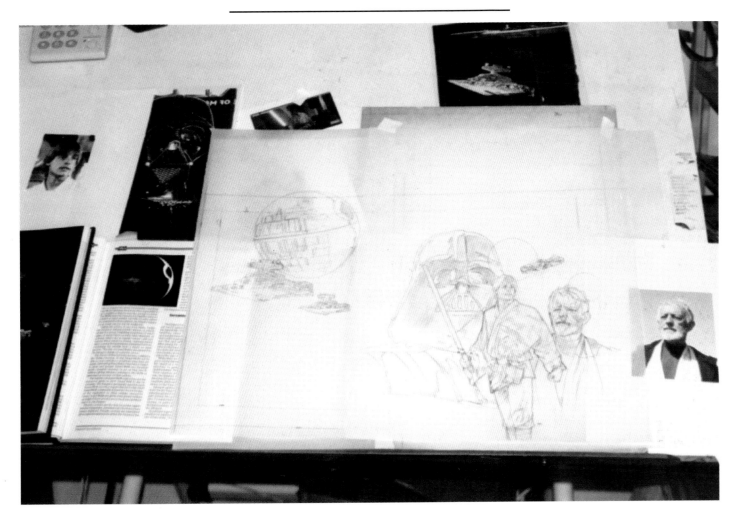

2) Once the rough is completed, Dave lays a second sheet of vellum over the first, beginning the process of tightening the drawing, while adding more details. At this stage, he works to solve any problems he may have with the drawing, making slight changes in positioning or design details. Over this second preliminary, he lays a third and final sheet of vellum, completing the process of detailing and shading, bringing the pencil drawing to the finished point. Dave's third preliminary is very tight and fully rendered. The detail at this stage allows him to use the drawing as reference during painting, as well as for the basic foundation of the painting. It is this final drawing which will be used to create the painting.

3) Dave's paintings are generally done on gessoed 2-ply Crescent 100 illustration board. He cuts a board to size and then applies a small pool of gesso. Using a 3" house painting brush, he brushes the gesso (with a small amount of water for thinning) into a thin, smooth, even layer across the entire surface.

Once the prepared board has dried, Dave marks a 1/2" image area border with a non-reproducing blue pencil. He then tapes the illustration board to the back of a larger, stiff board (here a piece of canvas board) with a medium-tack drafting tape along the blue border lines to ensure a clean mask. Using a sheet of graphite paper and a 1:1 photocopy of the drawing, he transfers the image to the prepared board. His pencil tracing over the drawing lines on the carefully positioned copy becomes the fourth version of the drawing.

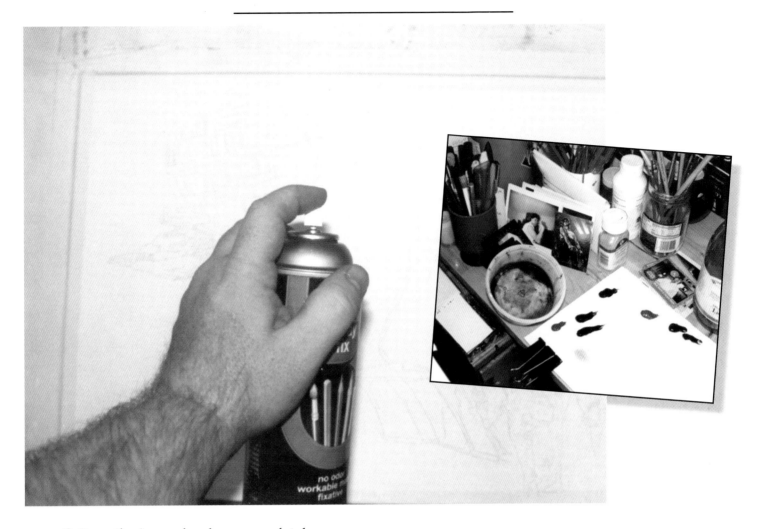

4) Once the image has been completely transferred, Dave goes over the lines with a kneaded eraser, lightening areas that will lie under thinner and lighter colored patches of paint, to ensure the pencil lines will not show through. The final image has only the faintest graphite line. Once the graphite has been thoroughly cleaned and lightened, he sprays the board with a fixative to prevent the graphite from dissolving in the oil paint.

For this piece of artwork, Dave wanted a texture on the background; which he built with gesso and a brush. He then lays out his paint palette and brushes as preparation for beginning the work. Because of the thinness of his layered technique, Dave must use only a sparse amount of oil paint.

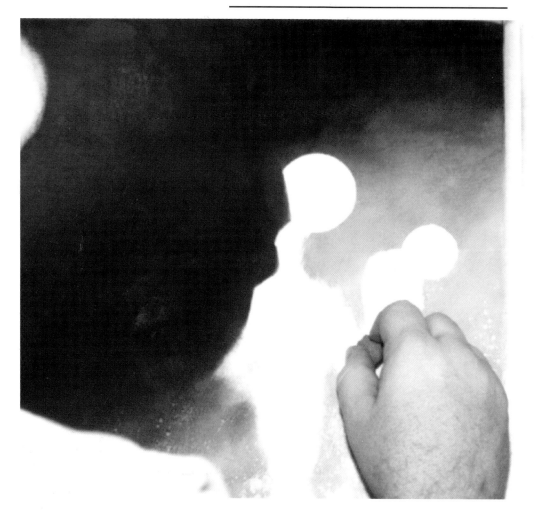

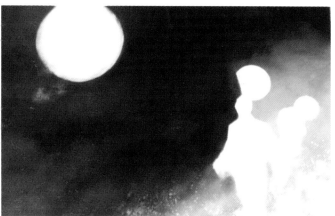

5) After the gesso texturing dries, Dave starts to apply the paint. Working with oils, Liquin medium and big brushes, he begins with the large background areas. He works around the figure areas and keeps the paint lighter on any background where a light point is to appear. After the paint has been laid down evenly, he goes in with a larger, soft brush and, with broad strokes, carefully blends the colors.

Dave then goes into the figure area with a kneaded eraser and pulls out paint in any areas he knows will need a brighter white background, such as areas to be painted with lighter tones or areas that will feature highlights.

Laying down an under-painting in specific areas, he blocks out the medium color ground for the Death Star and the Star Destroyers appearing in the painting. He also adds vivid color for the planet and sun, and uses acrylics to lay in the patch of blue sky behind the primary figures.

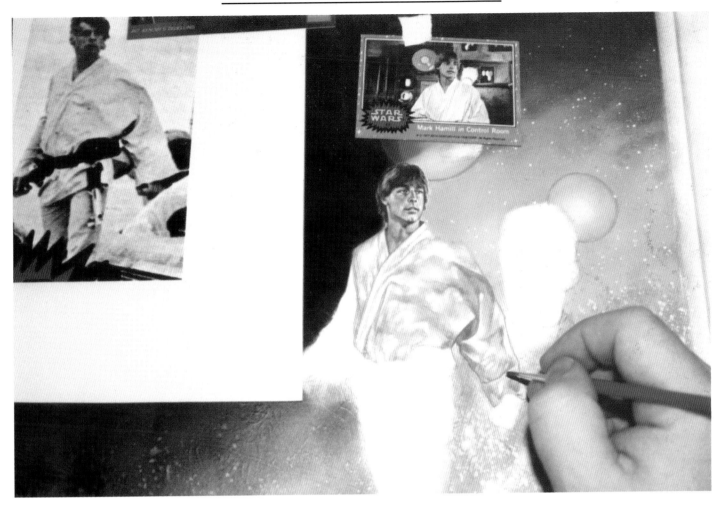

6) Once the background has dried, Dave begins work on the figure and detail in the foreground. He moves across the Luke figure filling in color, shading and details. While painting, he constantly refers to his finished drawing and the photo reference, to ensure accuracy in likeness, lighting, shadows and folds of the fabric. Dave works with a variety of inexpensive brushes. To gently blend the paint, he uses a very soft, 1" wide, flat brush. This provides a softer edge, and more realistically blended tones. While applying the detail, he uses a solvent-laden brush to remove areas of paint where lighter tones and highlights will later be placed. Because of the dark background shade on this piece, he will also need to add highlights to extenuate the brightness of the colors and whites. Dave then allows the painting to dry. The thin blending of his washes, in combination with his use of Liquin (which speeds drying) and a rack of floodlights, allows him to apply the many layers to his oil paintings in a very short period.

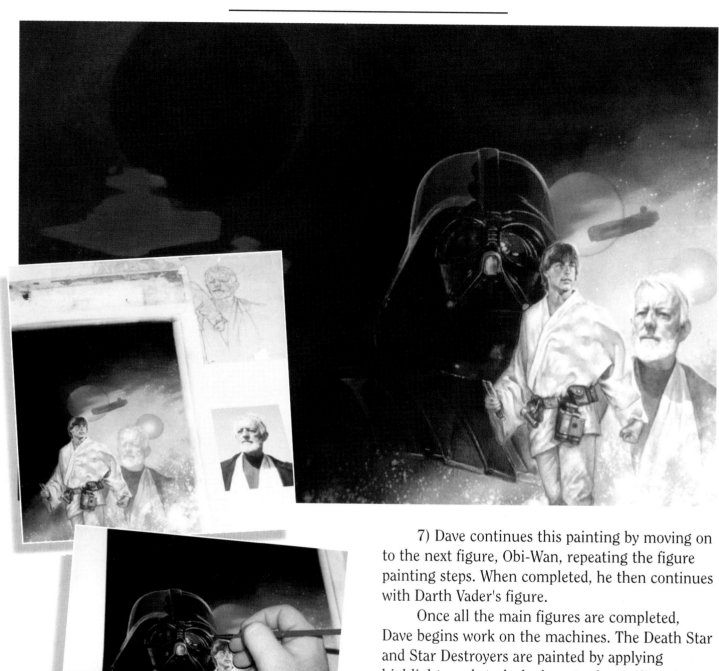

7) Dave continues this painting by moving on to the next figure, Obi-Wan, repeating the figure painting steps. When completed, he then continues with Darth Vader's figure.

Once all the main figures are completed, Dave begins work on the machines. The Death Star and Star Destroyers are painted by applying highlights and stark shadows to the medium tone under-painting. He usually performs this with markers and acrylics. In areas where bright whites are required but background paint has sullied the white of the board, he will use gesso to bring up the whitest highlights.

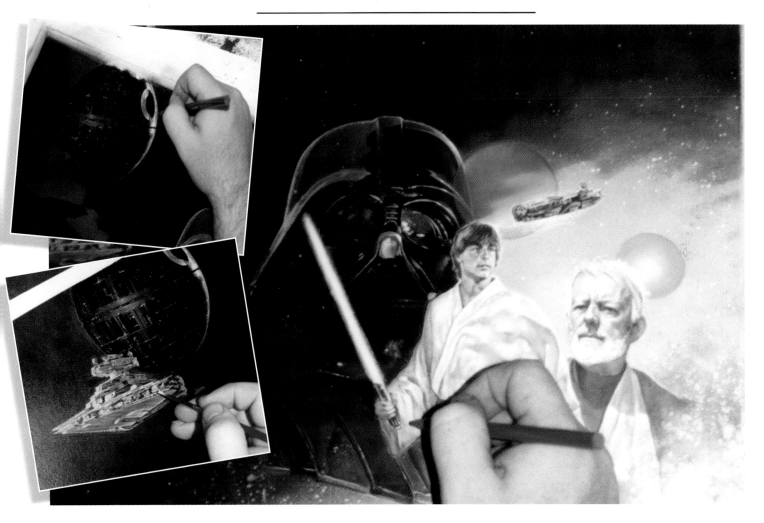

8) Once all the board work has been done, the painting is nearly completed. At this point, for a finished look, Dave adds detail work on costumes, weapons, ships, the Death Star and background textures. This is done with markers, acrylics, color pencil, gesso and razor scratches. Once he is happy with the finished painting, he adds his signature.

No artwork leaves Dave's studio without being photographed, and this is the final stage before the finished product is shipped to the publisher. When deadlines allow, he has transparencies of the piece made for his archives. Once the artwork has been photo-documented, Dave packages it and sends it to the publisher for production.

*{Editor's Note: You can see Dave's finished piece as a wraparound cover for this art book.}*

Dave Dorman, like Madonna, was born in Bay City, Michigan in the late 1950s. Being a "military brat," he grew up as a surfer kid in Hawaii, as well as a high school football star in Maryland. A sci-fi fan, Dave drove five hours round trip to see *Star Wars* on opening day in 1977, and has never been the same.

After a stint in college, then at the Joe Kubert School, Dave began his career as a professional illustrator in 1983 creating covers for *Heavy Metal* magazine. As the comics industry expanded, Dave was hired to do covers for many major publishers, as well as work for games, magazines and books. He is also noted for his Batman, Aliens, Predator and Indiana Jones artwork.

In 1990, Dave was assigned a dream project by Dark Horse comics. He was to illustrate the covers to *Dark Empire*; a new *Star Wars* mini-series which picked up where the *Return of the Jedi* left off. Since then, Dave has become an in-demand artist on numerous *Star Wars* projects and his company, Rolling Thunder Graphics, produces art prints of his work.

In 1993, Dave received the comics industry's highest honor, the Will Eisner Award, for his amazing paintings in the illustrated novel, *Aliens:Tribes*.

Dave is currently at work on his own project, *The Wasted Lands*, a series of illustrated novels set on an alternate Earth. His popular zombie character, Hitch, makes his major book debut this summer from Mojo Press in *Dead Heat*, written by Del Stone, Jr. and co-illustrated with Scott Hampton.

Dave lives in Florida with his wife, writer and illustrator Lurene Haines, and two cats, Frankie and Nemo.

Stephen Dodd Smith is a licensing and marketing consultant, and the founder and editor of *Monsterscene* magazine; a highly praised quarterly publication preserving the art of the classic horror film. He is Dorman's partner in Rolling Thunder Graphics.

Currently he is working on his first novel, *The Faerie Queen of Oz*, exploring the little talked about ancient history of L. Frank Baum's magical world of Oz.

Steve lives in a suburb of Chicago with his wife Chris, and their son Andrew.

Lurene Haines is an illustrator and writer. Her work in the comics industry includes cover art, interiors, comic scripts, and a *Star Wars* trading card. Her books, *Getting Into The Business Of Comics* and *A Writer's Guide To The Business Of Comics*, manuals for aspiring comics pros, have garnered critical acclaim and an Eisner Award nomination. Currently she writes and illustrates children's books.

Lurene and her husband Dave share their Florida home with two kooky cats.